A TO Z GREAT MODERN ARTISTS

A TO Z GREAT MODERN ARTISTS
ANDY TUOHY

WITH TEXT BY CHRISTOPHER MASTERS

CASSELL
ILLUSTRATED

Dedicated to Janet and Michael Tuohy
who always encouraged me to follow my own star.

An Hachette UK Company
www.hachette.co.uk

First published in Great Britain in 2015 by
Cassell, a division of Octopus Publishing Group Ltd
Endeavour House, 189 Shaftesbury Avenue
London WC2H 8JY
www.octopusbooks.co.uk
www.octopusbooksusa.com

Distributed in the US by Hachette Book Group
1290 Avenue of the Americas, 4th and 5th Floors, New York, NY 10020

Distributed in Canada by Canadian Manda Group
664 Annette St, Toronto, Ontario, Canada M6S 2C8

ISBN 978 1 84403 780 3
A CIP catalogue record for this book is available from the British Library
Printed and bound in China
10 9 8 7 6 5 4 3 2 1

CONTENTS

PREFACE 6

JOSEF **A**LBERS 10
FRANCIS **B**ACON 14
JEAN-MICHEL **B**ASQUIAT 18
JOSEPH **B**EUYS 22
LOUISE **B**OURGEOIS 26
GEORGES **B**RAQUE 30
MARC **C**HAGALL 34
GIORGIO DE **C**HIRICO 38
SALOUA RAOUDA **C**HOUCAIR 42
SALVADOR **D**ALÍ 46
MARCEL **D**UCHAMP 50
IBRAHIM **E**L-SALAHI 54
MAX **E**RNST 58
LUCIAN **F**REUD 62
ALBERTO **G**IACOMETTI 66
BARBARA **H**EPWORTH 70
DAVID **H**OCKNEY 74
EDWARD **H**OPPER 78
MAQBOOL FIDA **H**USAIN 82
ROBERT **I**NDIANA 86
JASPER **J**OHNS 90
FRIDA **K**AHLO 94
WASSILY **K**ANDINSKY 98
PAUL **K**LEE 102
YAYOI **K**USAMA 106
FERNAND **L**ÉGER 110
ROY **L**ICHTENSTEIN 114
RENÉ **M**AGRITTE 118

HENRI **M**ATISSE 122
JOAN **M**IRÓ 126
AMEDEO **M**ODIGLIANI 130
PIET **M**ONDRIAN 134
HENRY **M**OORE 138
BEN **N**ICHOLSON 142
SIDNEY **N**OLAN 146
GEORGIA **O**'KEEFFE 150
PABLO **P**ICASSO 154
JACKSON **P**OLLOCK 158
MARC **Q**UINN 162
ALEKSANDR **R**ODCHENKO 166
MARK **R**OTHKO 170
KURT **S**CHWITTERS 174
STANLEY **S**PENCER 178
VLADIMIR **T**ATLIN 182
CY **T**WOMBLY 186
MAURICE **U**TRILLO 190
BILL **V**IOLA 194
ANDY **W**ARHOL 198
BRETT **W**HITELEY 202
ZHANG **X**IAOGANG 206
JIRŌ **Y**OSHIHARA 210
LARRY **Z**OX 214

GLOSSARY 218

INDEX 220

ACKNOWLEDGEMENTS 224

PREFACE

Back in 2011, for no better reason than to amuse myself, I embarked on a series of illustrations of modern artists. At that point, the idea of these images being published couldn't have been further from my mind. Whilst designing a series of alphabet posters I decided to make artists my next subject and one sketch led to another, and another, and eventually enough for a book. I think an accessible, graphic introduction to some of the artists of the 20th and 21st centuries for a new generation is long overdue. Luckily my publisher agreed.

This book isn't a definitive textbook and I don't claim these are the 52 greatest modern artists of our time. At first glance, 52 might sound an adequate range, but it cannot come close to the number of artists who should be celebrated. It became a very hard task whittling down so many great talents, the inevitable consequence of which is omission. After much thought, and in consultation with art historian Christopher Masters, the entries became as you see in this book. The criteria I settled on was that the selected artists had to have had a profound and lasting impact on the art world; and that the scope of the book should represent a more global view of modern art than has been traditionally celebrated.

I hope that *A to Z Great Modern Artists* will encourage people to investigate further the non-Western artists featured here, including Sudan's Ibrahim El-Salahi, India's Maqbool Fida Husain, and Jirō Yoshihara and Zhang Xiaogang from Japan and China respectively.

Creating these illustrations wasn't always an easy ride; a son was born while I was working on the book and sleepless nights and deadlines are not happy bedfellows. But, like my subjects, my work is also my passion so I never stopped sketching and, inspired by each artist's story, the portraits gradually fitted together to become the book you hold in your hands. I hope you enjoy reading it as much as I enjoyed illustrating and designing it.

Andy Tuohy

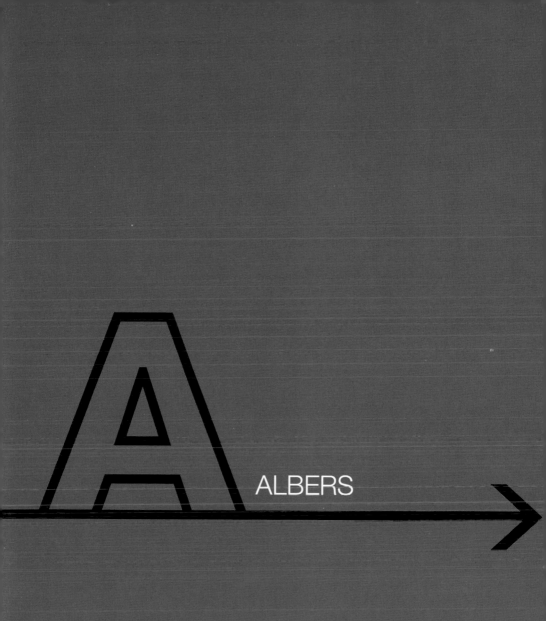

ALBERS

JOSEF
ALBERS

GERMAN
1888–1976

The work of Josef Albers (born 1888, Bottrop, Germany) rigorously explored the formal qualities of abstract painting, in particular the interrelationship of different colours in a single composition. He exerted a key influence on younger figures, including his student Robert Rauschenberg, and had a seminal role in the development of art education in Europe and America.

Albers's craftsman-like approach to art was influenced by the example of his father, Lorenz, who was a house painter and decorator. Lorenz did not, however, mark out his son for an artisan's career, and in 1908 Josef began his first posting as a schoolteacher in Bottrop. This was followed, from 1913 to 1915, by training in art education at the Königliche Kunstschule in Berlin and subsequently by more studies in Munich and at the newly established Bauhaus in Weimar.

In 1925 Albers became a master at the Bauhaus, where he emphasized discipline, mastery of materials and the analysis of formal problems, qualities exemplified by his abstract work in glass, in contrast to the expressionistic emphasis of his Swiss colleague Johannes Itten. Ultimately, however, Albers's approach became a key part of the Bauhaus legacy.

Albers and his wife, Anni, followed the Bauhaus throughout its odyssey across Germany as, owing to political pressures, it moved from Weimar to Dessau and, finally,

WHERE TO SEE ALBERS'S WORK

- Josef and Anni Albers Foundation Collection and Archives, Bottrop
- Museum of Modern Art, New York
- Solomon R Guggenheim Museum, New York
- Tate Modern, London

DID YOU KNOW?

Albers used his beloved pumpernickel sandwich as a metaphor for his artistic aims. He contrasted the simple use of bread, ham and mustard in his native Germany with the huge sandwiches of the United States as a way of criticizing what he considered to be the overblown paintings of American Abstract Expressionism.

Berlin. With the rise of Hitler in 1933, the school was forced to close, but, to his good fortune, Albers was simultaneously offered a post at the Black Mountain College in North Carolina. He worked there until 1949, counting Rauschenberg as one of his students, and subsequently taught at a number of institutions including Yale University.

Post-war work included the *Adobes*, a series that includes paintings with more specific titles such as *Variant: Brown, Ochre, Yellow* (1948). They have in common an architectural quality – from which derives their collective name – created by framing elements around a window-like field in the centre. By varying the arrangement of hues in each image, Albers created subtle effects of space, light and colour, demonstrating how the relationship between forms or hues was far more important than the individual elements themselves.

Albers's career shows how art can create perceptual effects that go beyond the works' physical reality, but this does not mean that he ignored their material qualities. His *Homage to the Square* series, begun in 1950, was made using the rough sides of Masonite pieces and consistently emphasizes the particular properties of the media. For Albers, art was both a transforming experience and a practical discipline.

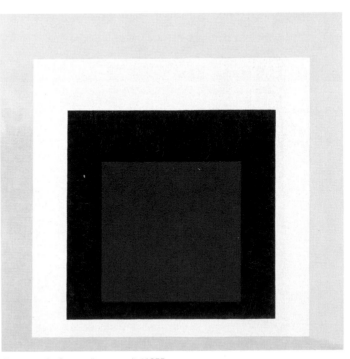

Homage to the Square, oil on masonite, 1955

BACON
BASQUIAT
BEUYS
BOURGEOIS
BRAQUE

FRANCIS
BACON

ANGLO-IRISH
1909–92

Francis Bacon (born 1909, Dublin, Ireland) achieved enormous success with his powerful and, at times, mannered figures. Although influenced by Pablo Picasso and other modernists, he created a distinctive style, absorbing the human body into dynamic, sometimes centrifugal compositions. Not only exhilarating in their forms and technique, his works also reflect the artist's private life.

In his late teens Bacon stayed in Berlin and Paris, before moving to London, where he spent most of his life. With no formal artistic training, he set out as a furniture and rug designer and also painted in a vaguely Cubist or Surrealist style. He really reached artistic maturity when he completed *Three Studies for Figures at the Base of a Crucifixion* (1944). This remarkable work, which combines references to the Crucifixion with the Greek deities of vengeance known as the Erinyes, or Furies, is a perverted triptych, with distorted phallic figures in front of a flaming-orange background.

Bacon's references to the imagery of the past also included the screaming heads based on Diego Velázquez's *Pope Innocent X* (1650) with a passing reference to Sergei Eisenstein's 1925 film *Battleship Potemkin*; figures in successive stages of movement, influenced by Eadweard Muybridge's photography; and bright hues inspired by artists as varied as Titian and Vincent van Gogh. Such a catalogue may suggest eclecticism, but it is striking how radically these pictures depart from the

WHERE TO SEE BACON'S WORK

- Des Moines Art Center, Iowa
- Dublin City Gallery The Hugh Lane
- Hirshhorn Museum and Sculpture Garden, Smithsonian Institution, Washington, DC
- Museum of Modern Art, New York
- Scottish National Gallery of Modern Art, Edinburgh
- Tate Britain, London

DID YOU KNOW?

Bacon, whose father was a racehorse trainer, was an inveterate gambler. In the late 1930s, when he despaired of his artistic career, he made his living by running an illegal casino. He remained a devotee of roulette and the casinos of Monte Carlo for the rest of his life.

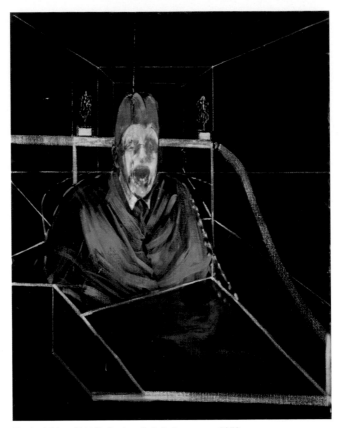

Number VII from Eight Studies for a Portrait, oil on canvas, 1953

compositions and, above all, the mood of their prototypes. Throughout his career, as it veered literally and metaphorically from light to dark and back again, Bacon remained a unique figure. His frenetic, curving brushstrokes, blurred with sponges or pieces of cloth, convey a visceral energy, however sophisticated his artistic allusions were.

Some of Bacon's most distinguished figures are of women, such as his portraits of the painter Isabel Rawsthorne, with expressive, almost sculptural heads. Most important of all, from the mid-1960s onwards, are the large portraits and triptychs of Bacon's lover George Dyer. In claustrophobic spaces with electric colours, Dyer is often naked, in poses ranging from eroticism to desperation, with his features wrenched out of shape. Bacon's anatomical liberties were taken while painting from memory or photographs – a process that facilitated the pictures made after Dyer's suicide in 1971. *Three Figures and a Portrait* (1975) includes Dyer and a winged Fury, a powerful reprise of the motif with which Bacon made his name over 30 years before.

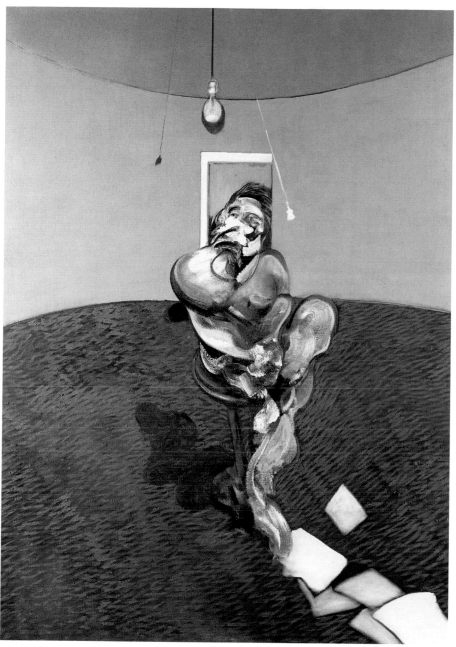

Portrait of George Dyer Talking, oil on canvas, 1966

JEAN-MICHEL
BASQUIAT

AMERICAN
1960–88

Jean-Michel Basquiat (born 1960, New York, USA) played a vital role in dragging graffiti, previously seen as an inferior preoccupation of youthful rebellion, into the mainstream of the art world and increasing its respectability and commercialism. He also helped to revitalize the career of his friend Andy Warhol, with whom he collaborated in the 1980s, before both men died in quick succession.

Basquiat was born into a family with roots in Haiti and Puerto Rico, and his artistic interests were fostered by his parents, especially his mother, who encouraged him to draw and often took him to New York's museums. As a teenager, he was involved with the Family Life Theater and Upper West Side Drama Group and during his time there he invented a disreputable character, SAMO ('Same Old Shit'). SAMO made a living preaching about a fake religion to those willing to be duped. He became a focal point of Basquiat's work and Basquiat painted him around New York City, together with the Lower East Side artist Al Diaz. Their spray-painted graffiti was aphoristic and included poems, rhymes and phrases such as 'SAMO as an end to mindwash religion, nowhere politics and bogus philisophy'. When their collaboration ended in 1979, Basquiat wrote 'SAMO is dead' around the neighbourhood. In addition to graffiti, Basquiat also made collages, T-shirts and postcards, and a number of his T-shirt designs were even revived in 2013 by the Japanese clothing chain Uniqlo.

WHERE TO SEE
BASQUIAT'S WORK
- Guggenheim Museum Bilbao
- MACBA, Museu d'Art Contemporani de Barcelona
- Museum Boijmans Van Beuningen, Rotterdam
- Museum of Modern Art, New York
- Whitney Museum of American Art, New York

DID YOU KNOW?
Basquiat mingled with the rich and famous during his short career, and even had a cameo appearance as a DJ in the video for Blondie's 1980 single 'Rapture'. He was hired at the last minute when the original DJ didn't arrive for filming.

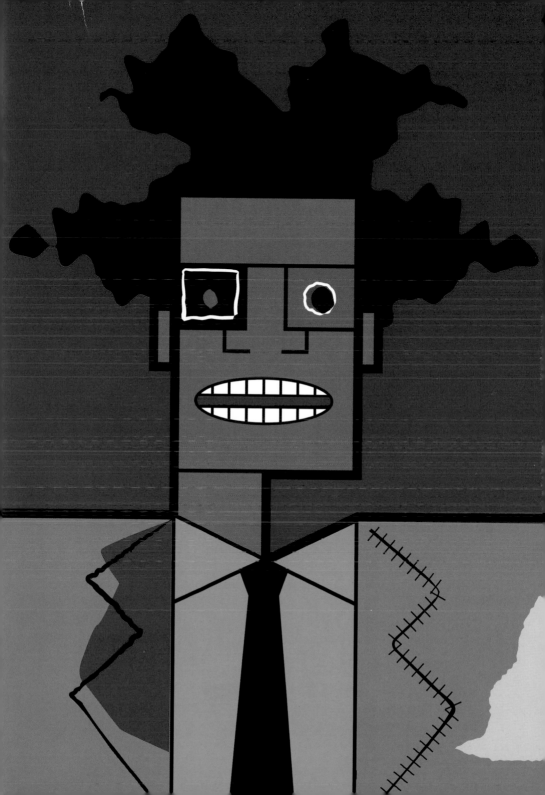

In the late 1970s Basquiat moved into more rarefied circles, partly as a result of his friendship with the film-maker Diego Cortez, and he held his first one-man exhibition in 1982. His childlike, untutored style was combined with complex allusions that struck a chord with dealers and collectors. His use of mixed media, combining coloured pens, pastels, pencils, charcoal, watercolours, oil crayons and acrylic paints, as in *2½ Hours of Chinese Food* (1984), showed the inquisitive, creative nature of his artistic output.

Like the previous generation of Pop artists, Basquiat incorporated the imagery of tragic events, including the assassination of John F Kennedy, as well as consumer brands into his work. Despite these links (with Andy Warhol in particular), Basquiat's

2½ Hours of Chinese Food, acrylic, oilstick and collage on canvas, 1984

images are more satirical, animated by references to racial stereotypes, even in his own self-portraits. They are also layered with imagery from different cultures, from classical Greece and Rome to Africa and the Caribbean, reflecting the pluralism of the society in which he lived. Basquiat was associated with pop (and Pop art) stars such as Madonna and Warhol.

Warhol's death deeply affected Basquiat, whose own sudden death from a heroin overdose at the age of 27 enhanced his legendary reputation in both the art world and popular culture. To paraphrase Wordsworth, he was the 'marvellous boy' of 1980s New York.

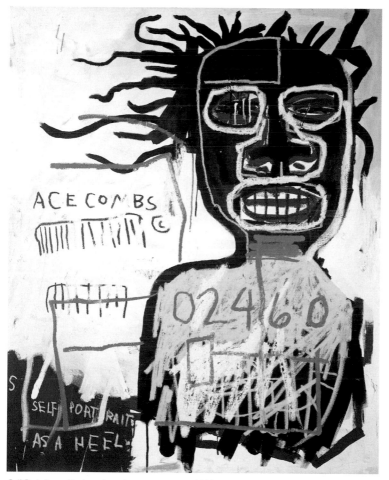

Self-Portrait as a Heel, acrylic and crayon on canvas, 1982

JOSEPH
BEUYS

GERMAN

1921–86

The German artist and activist Joseph Beuys (born 1921, Krefeld, Germany) redefined the concept of sculpture to include a range of activities that were intended to change society, and which incorporated performance, installation, happenings, graphic art and teaching. Through his performances and installations, Beuys sought to liberate the creativity of the observer. He was also a charismatic teacher and pedagogue, and a founder of the German Green Party.

In 1940 Beuys was conscripted into the Luftwaffe, and in 1943 he allegedly crashed in the Crimea and was discovered, and nursed back to health, by Tatar nomads (a story which later informed the titular 'English Patient' in Michael Ondaatje's novel). They treated him by wrapping his body with animal fat and felt – materials that later featured prominently in his work – and, as a by-product, they inspired his subsequent interest in shamanism.

After World War II, Beuys was trained at the Staatliche Kunstakademie in Düsseldorf and initially worked with conventional artistic materials, before switching in the late 1950s to 'found objects'. In the 1960s, Beuys began to cultivate an almost mythical status out of his rescue by the Tatar nomads, and used fat and felt in performances, installations and sculptures such as *Fat Chair* (1964), *Fat Room* (1967) and *Fat Felt Sculpture* (1963). He himself did not make a distinction between happenings and

WHERE TO SEE
BEUYS'S WORK

- Hessisches Landesmuseum, Darmstadt
- Tate Modern, London
- Kaiser Wilhelm Museum, Krefeld
- Louisiana Museum of Modern Art, Humlebæk, Denmark
- Museum für Gegenwartskunst, Basel
- Museum of Modern Art, New York
- Muzeum Sztuki, Łódzi

DID YOU KNOW?

At the Fluxus festival of 1964 in Aachen, a spectator punched Beuys on the nose. Beuys reacted to the flow of blood by holding up a crucifix in one hand and saluting with the other. Beuys's perception of himself as a martyr, and his talent for self-promotion, became an essential part of his activity.

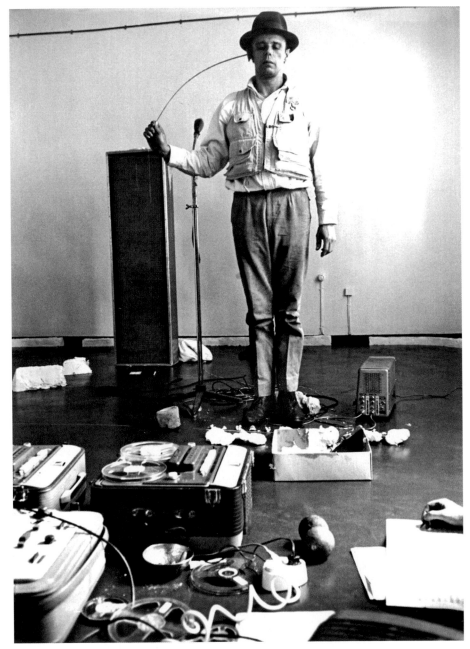

Fettraum (Fat Room), mixed media installation, 1967

things, since his concept of 'social sculpture' was defined in terms of process rather than finished objects. He saw art as therapeutic and as a source of energy that functioned, as he put it, as a heat reservoir or power station.

Often making analogies between his own activity and natural phenomena, Beuys followed Rudolf Steiner in placing particular value on the work of bees. At the *documenta 6* exhibition, held in Kassel in 1977, he created a giant honey pump, now in the Louisiana Museum at Humlebæk, as a form of organic sculpture. He also held performances involving a variety of animals, including several hares and a coyote. One of the best-known, *How to Explain Pictures to a Dead Hare* (1965), saw Beuys, with his head coated in honey and gold leaf, interpreting the works of his exhibition to a dead hare while the public viewed the 'Action' through the gallery windows.

The 1970s was a period of international renown for Beuys. His dismissal in 1972 from the teaching staff of his alma mater, the Staatliche Kunstakademie in Düsseldorf, was a *cause célèbre*. However, the Freie Internationale Universität, which Beuys founded in Düsseldorf in the same year, offered an alternative to the academy and other mainstream institutions. It was dissolved in 1988, two years after Beuys's death, but has inspired similar initiatives elsewhere. Ultimately, Beuys was an enabler, a cultural leader who inspired collective acts – such as the planting of seven thousand oaks at *documenta 7* (1982) – that were arguably more symbolic than practical in function, but immensely important to the development of art.

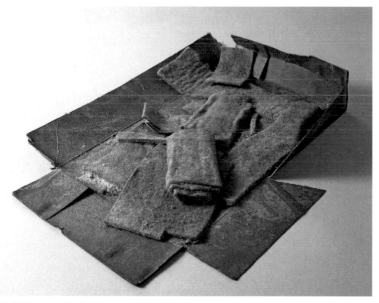

Fat Felt Sculpture (Fat Battery), fat, felt and cardboard box in metal and glass vitrine, 1963

LOUISE
BOURGEOIS

FRANCO–
AMERICAN
1911–2010

Louise Bourgeois (born 1911, Paris, France) produced some of the most arresting and thought-provoking sculptures that were made after World War II. Huge bronze spiders; wooden stick figures; interactive installations and towers of steel and fabric: all these works command the spaces in which they are installed and confront issues of identity, sexuality and, above all, femininity.

Louise Bourgeois was born into a Parisian family of tapestry weavers and restorers. Although she initially studied mathematics at the Sorbonne, during the 1930s she began to work in a variety of artistic media, defying the anti-modernist prejudices of her father. Crucially, in 1938 she married the American critic Robert Goldwater, with whom she moved to New York, the city that was to be her home for more than 70 years. As well as joining the Art Students League, she spent the period of World War II working with European exiles such as André Masson and Joan Miró.

Bourgeois's interest in exploring the unconscious was shared not just with these erstwhile Surrealists but also with the American Abstract Expressionists. Although she exhibited with the latter, her post-war prints and sculptures were clearly figurative. This did not mean that her explorations of existential states and emotional crises could ever be described as naturalistic. She often merged biological and inanimate forms, as in the stick-like wooden sculpture called *Sleeping Figure* (1950).

WHERE TO SEE
BOURGEOIS'S WORK

- Centre Georges Pompidou, Paris
- Kunstmuseum, Bern
- Musée d'art contemporain de Montréal
- Museum of Modern Art, New York
- Solomon R Guggenheim Museum, New York
- Tate Modern, London

DID YOU KNOW?

Bourgeois was an indefatigable supporter of gay and transgender rights. In the final year of her life, she donated *I Do* (2010), an edition of prints depicting two flowers on a single stem, in order to raise money for the Freedom to Marry campaign in the United States.

As her career developed, Bourgeois became bolder, both in her use of unconventional media such as latex and in the sexual and psychological content of her work. In many ways, she was ahead of her time and it was only in her later years that she was fully appreciated, perhaps due to the wider acceptance of feminist ideas.

With the resources that her success enabled, in 1980 Bourgeois took possession of a large studio in Brooklyn, which allowed her to work on a more ambitious scale. Cell-like spaces, filled with textiles and personal and domestic objects, became a kind of psychological self-portrait, while her celebrated bronze spiders alluded to her weaving roots, spiced with the ingredient of horror. The title of the piece *Maman* (1999) was by no means incidental, its towering structure and the marble eggs in its sack combining in a contradictory image of motherhood; while *I Do, I Undo and I Redo* (2000) consisted of mirrored towers housing sculptures of a mother and child.

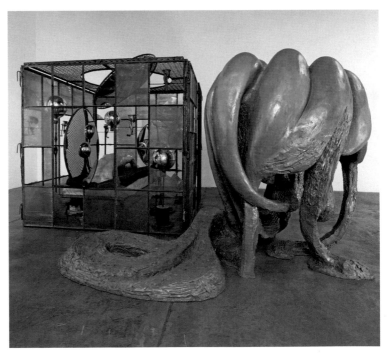

In and Out, metal, glass, plaster, fabric and plastic, 1995

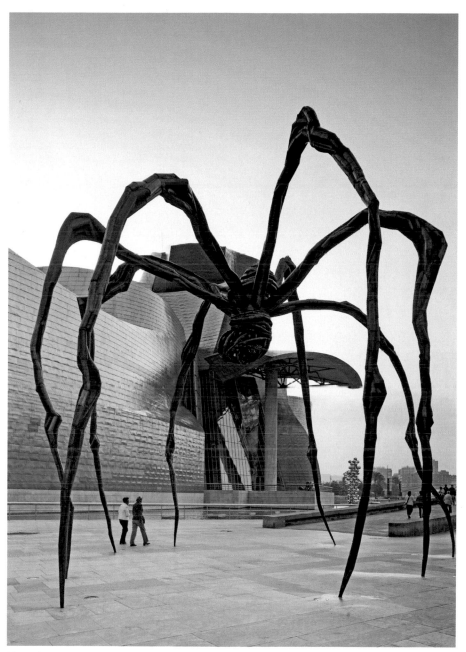

Maman, bronze, marble and stainless steel, 1999

GEORGES
BRAQUE

FRENCH
1882–1963

Georges Braque (born 1882, Argenteuil, France) collaborated with Pablo Picasso in creating the new pictorial language of Cubism. His subsequent career consisted of subtle variations and evolution, rather than the radical innovations of his youth.

In 1897 Braque trained at the local art school and, after military service, attended the Académie Humbert and the École des Beaux-arts in Paris. In 1905 he encountered the Fauve paintings of André Derain and Henri Matisse at the *Salon d'automne*, and, like his friend Othon Friesz, produced flat, decorative compositions with intense colours, as in *Olive Tree near L'Estaque* (1906).

Braque's Fauvism was thrilling but short-lived. By the end of 1907 he had developed a more sombre, plastic idiom, as a result of seeing both a retrospective of Paul Cézanne and Picasso's *Les Demoiselles d'Avignon* (1907). The following summer he completed his first true Cubist pictures, including *Houses at L'Estaque* (1908), with rectangular forms that gave rise to the critic Louis Vauxcelles's famous comment about 'reducing everything…to cubes'. The term 'Cubism' was not, at first, complimentary.

It was also not entirely accurate. Over the next few years Braque and Picasso developed a style of intersecting and overlapping planes that seemed to define both the forms and the space around them. There was some emphasis on triangles in compositions such as Braque's *The Portuguese* (1911–2), but not much on cubes.

WHERE TO SEE BRAQUE'S WORK

- Centre Georges Pompidou, Paris
- Kunstmuseum, Basel
- Kunstmuseum, Bern
- Kunstsammlung Nordrhein-Westfalen, Düsseldorf
- The Louise and Walter Arensberg Collection, Philadelphia Museum of Art
- Museum of Modern Art, New York

DID YOU KNOW?

Braque was the exact opposite of the tortured bohemian. In his youth he was a talented dancer and boxer. He was introduced to Marcelle Lapré by Picasso and remained married to her for more than 50 years. In death, he was given state honours at his funeral and a eulogy at the Cour carrée of the Louvre.

With their shallow pictorial space, the paintings rigorously expressed the flatness of the canvases on which they were made. A few stencilled letters and naturalistic details helped to make the images legible, but in general these so-called 'Analytical Cubist' paintings were hermetic in meaning, as well as being void of colour.

In 1912 Braque reacted to this austerity, incorporating fragments of naturalism such as imitation wood graining and enriching the paint by mixing it with sand. He also invented *papiers collés* – images, such as *The Daily Paper* (1913–14) made from

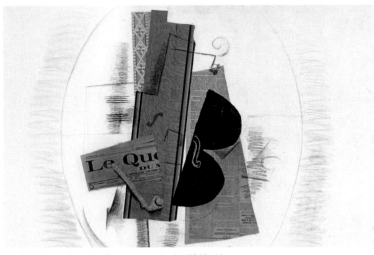

The Daily Paper, charcoal, collage, paper and paint, 1913–14

pasted pieces of paper. The new technique inspired the 'Synthetic Cubist' oil paintings that Picasso and Braque produced over the next few years. The compositions of these crisp, highly ordered pictures were built up from coloured planes, with descriptive details and, sometimes, decorative flourishes such as pointillist dots.

Braque later introduced more irregular patterns, rich colours and textures, and classical elements such as semi-nude basket carriers. During the 1930s he developed a purer brand of classicism, drawing on Greek vases and intaglios. Although a darker mood entered his work towards the end of the decade, after World War II Braque became associated with the uplifting motif of a bird. This image, which first appeared in the celebrated *Studio* series, was the basis in 1953 of his memorable ceiling paintings for the Salle Henri II in the Louvre. While Braque continued to make lithographs and etchings in his later years, many of his works were large in scale and often intended for public settings, such as the stained-glass windows, which he designed in 1954, for the church at Varengeville in Normandy.

CHAGALL
DE CHIRICO
CHOUCAIR

MARC
CHAGALL

RUSSIAN
1887–1985

This member of the École de Paris was justly renowned for his poetic, folkloric paintings. Although his work heavily reflected his upbringing in a Jewish community in Belarus, it proved highly adaptable to the Western art market.

Marc Chagall (born 1887, Vitebsk, Belarus) studied with a local artist before moving in 1907 to St Petersburg, where his output included a number of images of Jewish life. It was not, however, until he emigrated to Paris in 1910 that he made real artistic progress, with evocative, fantastical paintings such as *The Fiddler* (1912), which took inspiration from the new city as well as his native land. After revisiting Vitebsk, via Berlin, he was prevented from returning to France by the outbreak of World War I.

Chagall's wedding in 1915 to Bella Rosenfeld had a profound effect on his art. His personal happiness following the marriage is reflected in some remarkable paintings of levitating lovers and other magical subjects, including music-playing goats, oversized chickens and fairies, all depicted with his characteristic soft palette.

After the 1917 October Revolution, Chagall was given a succession of administrative and teaching posts, as well as design work in the theatre, but political appointments and infighting drove him abroad in 1922. He eventually returned to Paris, where he threw himself into graphic art and book illustration, as well as into making vibrant, large-scale pictures with fantastic themes. Due to its often absurd subject matter,

WHERE TO SEE CHAGALL'S WORK

- Art Institute of Chicago
- Centre Georges Pompidou, Paris
- Musée National Marc Chagall, Nice
- Museum of Modern Art, New York
- Stedelijk Museum, Amsterdam
- Tretyakov Gallery, Moscow

DID YOU KNOW?

Chagall worked right up until the day of his death and in his penultimate year even published a book with one-time Rolling Stone bassist Bill Wyman. *Chagall's World* features more than 50 reproductions of Chagall's works, Wyman's own photography of the famous artist and interviews between Chagall and his friend, the poet and artist André Verdet.

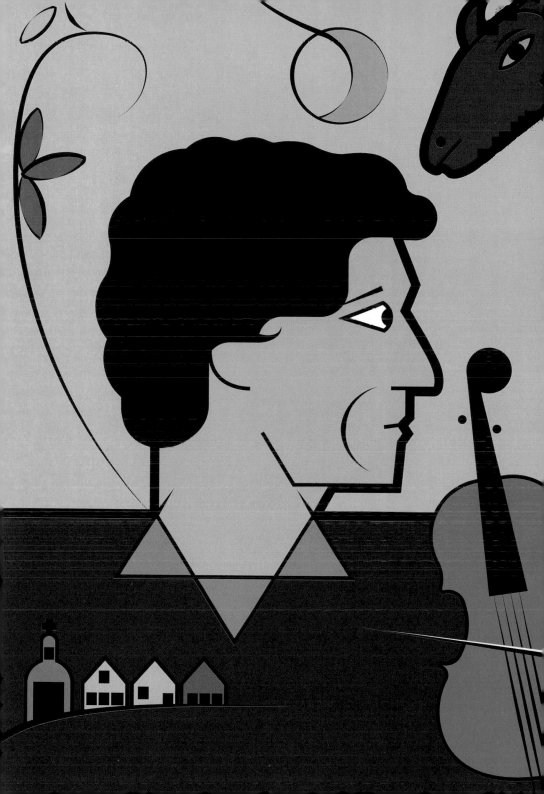

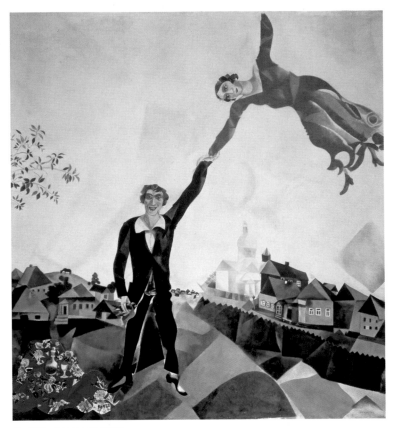

The Walk, oil on canvas, 1917

including anthropomorphic animals and a disregard for the laws of time and space, his work inevitably drew comparisons with the Surrealists, although he remained resolutely independent of their movement.

The tide of anti-Semitism in the 1930s affected Chagall and his art profoundly. His best-known work of this time, *White Crucifixion* (1938), shows Christ on the cross, flanked by the destruction of Jewish homes. The artist emphasizes Christ's Judaism through his clothing and that of the mourners around him. By combining Christian iconography with scenes of persecution, Chagall makes a damning critique of the contemporary political landscape. In 1941 he was compelled to flee France for the United States. In New York, he indulged his intense colourism in designs for the ballet as well as ambitious canvases, and in 1946 he was honoured with a retrospective at the Museum of Modern Art.

The White Crucifixion, oil on canvas, 1938

Although Chagall subsequently returned to France, he chose not to settle in Paris but in St-Paul-de-Vence, near Nice. Here, in the 1950s and 1960s he worked in ceramic, sculpture and mosaic, as well as producing large paintings of biblical themes, now in the Musée National Marc Chagall in Nice. His public commissions included ceiling decorations for the Paris Opéra (1964), but it was in his numerous stained-glass windows, for Christian, Jewish and secular settings, that he produced his most vivid late creations.

GIORGIO DE CHIRICO

ITALIAN
1888–1978

Giorgio de Chirico (born 1888, Volos, Greece) was renowned for his dream-like settings and striking juxtapositions that bring together unrelated objects from modern life and antiquity. These qualities drew praise in the 1920s from the French Surrealists, who welcomed him into their fold even as de Chirico entered a more conservative, classical phase. As the Surrealists became ever-more critical of de Chirico's new direction, however, the association ended acrimoniously. Recently, his late work, including his sculpture, has received new critical attention, although the second decade of the 20th century was undoubtedly his most fertile period.

Giorgio de Chirico's eclectic attitude to ancient art and architecture can partly be attributed to his upbringing. He was born to Italian parents in Volos, Greece, and had formative experiences in strongholds of classicism as diverse as Athens, Florence, Rome, Turin and, from 1906 to 1908, Munich. It has been suggested that the series of paintings described as *Squares of Italy (Piazze d'Italia)* should more accurately be called 'Squares of Munich'. The Bavarian capital was also the scene of de Chirico's important contact with the Symbolism of Max Klinger and Arnold Böcklin.

In 1911 de Chirico followed his artist brother, Andrea, who was known by the pseudonym 'Alberto Savinio', to Paris. Here he created a series of remarkable pictures in which arcaded piazzas, with illogical perspectives and dramatic contrasts of light

WHERE TO SEE DE CHIRICO'S WORK

- Estorick Collection of Modern Italian Art, London
- Fondazione Giorgio e Isa de Chirico, Rome
- Metropolitan Museum of Art, New York
- Peggy Guggenheim Collection, Venice

DID YOU KNOW?

De Chirico never forgave the art world for its derision of his later works but he was known to fake his own early works and fooled many collectors. As a result art dealers used to joke that de Chirico's bed was six feet off the ground due to the number of 'early works' he kept 'discovering' there.

and shade, are filled with oversized sculptures and incongruous modern details. *Ariadne* (1913), for example, contains both the statue of a mythological character and a steam engine, without a single living figure. It is one of a series of eight paintings where the mythical title figure takes a prominent, though puzzling, role.

This sense of the uncanny intensified in 1914, when de Chirico began to introduce faceless mannequins into his work, and culminated in the 'metaphysical painting' that he produced during his military service in Ferrara during World War I. Instead of depicting troops, de Chirico painted claustrophobic rooms filled with empty canvas stretchers, useless piles of mathematical instruments and the odd piece of confectionery. In such works, the set-squares evoke a world of reason and logic that everything else in the paintings spectacularly undermines.

By 1918 de Chirico had began to contribute, together with his friend Carlo Carrà, to the periodical *Valori plastici*, in which he advocated a return to classical values that corresponded to Italy's conservative atmosphere at this time. Over the next decade, de Chirico's classicism embraced some characteristically idiosyncratic subjects, including crowds of gladiators in modern interiors, and a visionary novel, *Hebdomeros*, published in Paris in 1929. Eventually, the shift in his work led him to be disowned by his former supporters in the Surrealist movement.

In his final decades de Chirico, living mostly in Rome, combined an emphasis on traditional artistic techniques with a strange *mélange* of imagery. Baroque self-portraits alternated with mannequin-like sculptures, while he also produced

Ariadne, oil and graphite on canvas, 1913

some rather dubious versions of his earlier work in response to its popularity. Yet, despite the criticism he received from fellow artists and critics, he continued to find moments of inspiration, animating the forms of classical culture with a sense of the marvellous and unfamiliar.

Two Masks, oil on canvas, 1916

SALOUA RAOUDA CHOUCAIR

LEBANESE
Born 1916

This Lebanese artist was a pioneer of abstract painting and sculpture in the Middle East. Her distinctive work shows themes that run throughout her career, in particular modular and architectural qualities that are derived from both European modernism and the traditions of Arab design.

Following her education at the al-Ahliyya National School for Girls, Saloua Raouda Choucair (born 1916, Beirut, Lebanon) learned to draw and paint from the distinguished Lebanese artists Moustafa Farroukh and Omar Onsi. In 1943 a visit to Egypt opened her eyes to the formal qualities of Islamic art and architecture, which she believed 'reached into the essence of the subject'. Back in Beirut, in the mid-1940s, she was also a co-founder of the influential Arab Cultural Club.

In 1948 Choucair began three years of study in Paris, where she joined the École des Beaux-arts and attended the studio of Fernand Léger, whose influence can be seen in the stiff and bulky nudes of *Les Peintres célèbres* (1948–9). While Choucair made a number of figurative or semi-abstract works during her time in Paris, including *Paris-Beirut* (1948) contrasting the new city and her homeland, she also became associated with the lesser-known art school, Atelier d'art abstrait. Although she had actually been producing abstract modular paintings since 1947, this further encouraged her move towards non-objective art.

WHERE TO SEE CHOUCAIR'S WORK

- Saloua Raouda Choucair Foundation, Beirut
- Tate Modern, London

DID YOU KNOW?

Choucair continued to live in Beirut throughout the Lebanese Civil War (1975–90). Surviving examples of work from her apartment bear scars, including splinters of glass, from the bomb attacks of that time.

During the following decade, after returning home to Beirut, Choucair began to model and carve sculptures characterized by the interplay of solids and voids and by an emphasis on curved lines. These curvilinear and interlocking shapes also dominated her paintings, such as *Composition in Blue Module* (1947–51), and tied her oeuvre together, so that forms from the paintings were reflected in her sculptures and textiles throughout her career.

She frequently worked in complex series, including, in the 1960s, the works known as *Interforms* – simple cubes or blocks containing intricate internal forms. This was followed by numerous modular sculptures with parts that stack together in a flexible way. Like a stanza of Arabic poetry, each module can stand alone or be read as part of a whole, inspiring Choucair to give the works titles such as *Poem Wall* (1963–5).

Composition in Blue Module, oil on canvas, 1947–51

While continuing her experiments with interlocking and modular elements, in the 1970s and 1980s Choucair also gave her work a sense of lightness and motion by incorporating transparent materials including plastic and water in pieces such as *Water Lens* (1969–71). She also began to create public sculptures. Although not all of these have survived the upheavals of life in Beirut, the bench of 1998 in the Mir Amin Garden, a curved structure made from 17 expressive stone pieces, exemplifies Choucair's work at its most graceful.

DALÍ
DUCHAMP

SALVADOR
DALÍ

SPANISH
1904–89

When Salvador Dalí (born 1904, Figueres, Catalonia, Spain) was asked in 1973 about his place in the history of art, he simply replied, 'The First, the First'. Critics have not always confirmed this opinion, but he was unquestionably one of the most popular and distinctive artists of the 20th century. As a leading member of the Surrealist movement in the late 1920s and 1930s, he created precise, dream-like images filled with his favourite motifs, from limp watches and crutches to his own moustachioed features. His later work recycles some of this imagery but also includes spectacular versions of traditional themes. In *Christ of St John of the Cross* (1951), for example, Christ hangs from the cross while suspended in mid-air.

The young Dalí spent many of his summers on the Catalan coast at Cadaqués, the subject of memorable pictures that also include his beloved sister, Ana María. After flirting with Impressionism and Cubism, he followed these key artistic styles to their birthplace, Paris. In 1929 he joined the Surrealists, collaborating with Luis Buñuel on the experimental film *Un chien andalou* (1929) and attracting the admiration of the Surrealists' leader, the poet André Breton.

Dalí's work combined Freudian symbols with a method he dubbed 'paranoia-criticism'. This was derived partly from his own morbid obsessions, for example with *The Angelus* (1857–9), a canvas by Jean-François Millet, which Dalí perceived as filled with

WHERE TO SEE
DALÍ'S WORK
- Espace Dalí Montmartre, Paris
- Gala-Salvador Dalí Museum, Figueres
- Kelvingrove Art Gallery and Museum, Glasgow
- Museo Nacional Centro de Arte Reina Sofía, Madrid
- Salvador Dalí Museum, Saint Petersburg, Florida

DID YOU KNOW?
Salvador was named after his elder brother, who had died a year before his own birth. His parents believed that he was a reincarnation of the older child, planting the seeds of one of his many psychological complexes.

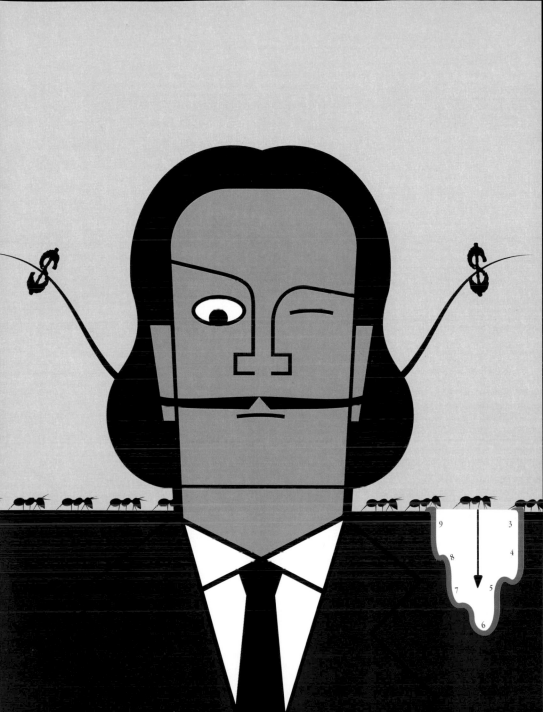

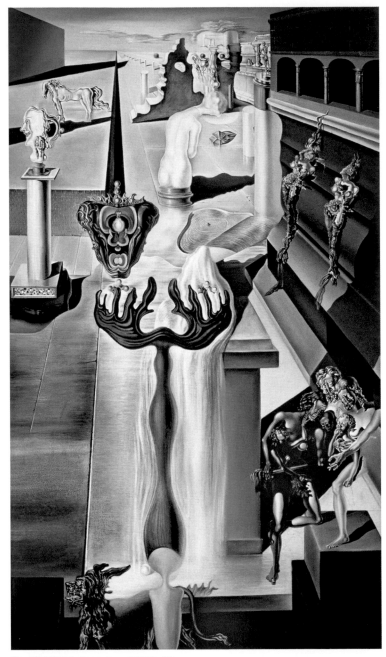

The Invisible Man, oil on canvas, (*c.*1929–32)

erotic violence. Dalí produced a range of pictures making highly irrational associations that appear to provide a deep insight into his psyche. In a similar vein, he began to create forms that simultaneously suggest more than one object. His first full-length double image was *The Invisible Man* (c.1929–32), described by the artist as a 'personage with benevolent smile … which still serves to exorcise all my terrors'. The painting seems initially to be a post-apocalyptic landscape, out of which a male figure appears. His combination of the two images causes certain features to combine into different interpretations – the cloud and the neck of the statue are intentionally distorted to take the shape of the man's head and body.

The artist was also criticized for his repetition of signature motifs. The limp watch became ubiquitous in Dalí's career, but it undoubtedly made a powerful debut in *The Persistence of Memory* (1931). In this acknowledged masterpiece a dream-like view of Portlligat is the setting for a sleeping self-portrait adorned with one of the famous floppy timepieces. Although they undoubtedly have sexual undertones, the watches, all stopped at different times, are also metaphors for the realm of the unconscious.

Around this time Dalí also published *The Visible Woman* (1930), a literary expression of paranoia-criticism. It was followed by numerous texts, including *Declaration of the Independence of the Imagination and the Rights of Man to his own Madness* (1939), *Hidden Faces* (1944) and *Diary of a Genius* (1965), as well as his autobiography, *The Secret Life of Salvador Dalí* (1942). His writings are peppered with bizarre statements that combined to cultivate his unique image as an inspired eccentric. There can be no doubt, however, that Dalí's output is carefully contrived, simulating the unconscious and even the psychotic rather than actually expressing it.

Although Dalí's production in sculpture is relatively limited, pieces such as *Lobster Telephone* (1936) and *Mae West's Lips Sofa* (1936–7) have become synonymous with Surrealism and with Dalí's emphasis on double images. *Mae West's Lips Sofa* is just one manifestation of Dalí's plan to make an entire room based on his favourite actress's face. This was finally created at the Dalí Museum in Figueres, which opened in 1974.

By the mid-1930s some of Dalí's provocations seemed to be directed at his own left-wing Surrealist colleagues. He made some paintings, and statements, that were highly ambiguous about both Lenin and Hitler, and was forced to declare to his colleagues that he was not sympathetic to Fascism. The rift with the Surrealists was sealed when he moved during World War II to the United States, where his work in advertising and commercial cinema inspired the anagram and sobriquet 'Avida Dollars'.

In the post-war period Dalí spent much of his time in Spain, despite the continuing dictatorship of General Franco, which had kept other artistic compatriots, such as Pablo Picasso, in exile. In Figueres, the Dalí Museum, dedicated to his memory fifteen years before his death, was flamboyantly constructed in an old theatre, turning it into a place of pilgrimage for his admirers. It is one of a trio that also includes his house in Portlligat, near Cadaqués, and the castle at Púbol, which he remodelled into a monument and home for his formidable wife, Gala.

MARCEL
DUCHAMP

FRENCH
1887–1968

As a member of the Dada movement, Marcel Duchamp (born 1887, Blainville, Normandy, France) did more than anyone to redefine the concept of art. Although his period of intense activity around World War I was brief, he was highly influential, inspiring conceptual, Minimalist and Pop artists later in the 20th century.

The brother of the artists Jacques Villon, Raymond Duchamp-Villon and Suzanne Duchamp, Marcel began to attend the Académie Julian in 1904, though he was more interested in billiards than in his studies, and in the following years he made a living from publishing cartoons. His painting evolved from Impressionism to Post-Impressionism and Fauvism until, in 1912, he co-founded the Cubist group known as the Section d'Or.

Duchamp's celebrated *Nude Descending a Staircase No. 2* (1912) reflects a variety of influences, including the photography of Eadweard Muybridge. It is essentially a Cubist picture, though its dynamic quality alienated some of his colleagues because of its similarity to Italian Futurism. In the event, the painting's most important public exposure took place not in Paris but in New York, at the *Armory Show* of 1913.

The ensuing years were Duchamp's most fertile period, in which he explored the operation of chance, for example in a variety of musical scores, and made the first 'ready-mades'. These were mundane objects altered in the most simple ways, often

WHERE TO SEE
DUCHAMP'S WORK

- The Louise and Walter Arensberg Collection, Philadelphia Museum of Art
- Museum Ludwig, Cologne
- Museum of Modern Art, New York
- National Gallery of Canada, Ottawa
- Tate Modern, London
- Yale University Art Gallery, New Haven, Connecticut

DID YOU KNOW?

Duchamp had a lifelong obsession with chess, which was an occasional subject of his pre-war paintings and later became his main activity. After becoming chess champion of Haute-Normandie in 1924, he participated in various international tournaments before co-writing and designing a book on chess strategy (1932).

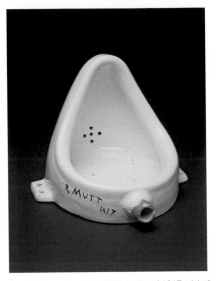

Fountain, porcelain urinal, 1950 (replica of 1917 original)

by inverting them or otherwise changing their position, presented for exhibition as a challenge to the traditional notions of creativity. The *Bicycle Wheel* of 1913 (lost; replicas exist) was followed four years later by the urinal laid on its back, known as *Fountain* (lost; replicas exist). Duchamp also took a direct aim at artistic genius by reproducing Leonardo's *Mona Lisa* (*c*.1503–6) and inscribing it with 'L.H.O.O.Q.' (1919), which, when read aloud in French, means 'she has a hot arse'.

Duchamp's cultivated crudeness had first appeared around 1912 in a series of Cubist works that seemed to be about the sexual activity of bits of machinery. This somewhat unromantic theme culminated in *The Bride Stripped Bare by Her Bachelors, Even*, created from 1915 to 1923, when the artist was living mostly in New York. The image represents one biomorphic bride being courted by nine mechanistic bachelors who do not get anywhere near her. Pursuer and pursued are, in fact, painted on two separate panes of glass, forming the world's most memorable symbol of sexual failure and frustration.

While in the United States, Duchamp formed close relationships with important patrons and artists, including Man Ray, who famously photographed him in drag as his alter ego Rose Sélavy, a homonym for the suggestive phrase 'Eros, c'est la vie' (Eros – that's life). Yet, despite this stimulation and success, Duchamp largely withdrew from the art world after his return to France in 1923. He did participate in the odd Surrealist exhibition, but most of his artistic activities were private optical experiments, such as the painted, rotating discs intended to create an illusion of depth, or miniature reproductions of earlier pieces. His most ambitious late work, *Given: 1. The Waterfall; 2. The Illuminating Gas* (1946–66), a three-dimensional tableau of a woman with her legs apart, was kept secret until his death.

In his last years Duchamp was hailed as an inspirational figure by a new generation of artists, including pioneers of Pop such as Richard Hamilton and Andy Warhol. In 1965–6 Hamilton created the most painstaking tribute, a replica of *The Bride Stripped Bare by Her Bachelors, Even*, for the Tate Gallery in London.

EL-SALAHI
ERNST

IBRAHIM
EL-SALAHI

SUDANESE
BORN 1930

Ibrahim El-Salahi (born 1930, Omdurman, Sudan) is one of the leading artists of Africa and the Arab world, who has sought a synthesis between Western modernism and Islamic traditions, above all Arabic calligraphy. This rich visual vocabulary is the hallmark of the Khartoum School, an artistic style pioneered by El-Salahi that combines Western modernist influences with traditional Afro-Arabic motifs.

El-Salahi began his education at his father's Qur'anic school, where he would decorate the writing slates of other pupils. Here he became adept in the Sudanese form of Arabic calligraphy. Having studied at Khartoum's School of Design, El-Salahi came to London in 1954 on a government scholarship. As well as receiving an academic training at the Slade School of Fine Art until 1957, he was inspired by the city's great museums, which enabled him to study artefacts from a wide range of cultures and to discover the works of the great European masters. The experience laid the foundations for his subsequent synthesis of styles. In London, he developed a free style of brushwork, marrying the poetry and precision of Islamic calligraphy with the expressiveness and emotion of Western abstract painting.

Despite these developments, much of El-Salahi's work in his Slade period was relatively conventional. *Brothel* (1955) borrows readily from French art in both its execution and subject-matter, with moody lighting and pointillist effects combined

WHERE TO SEE
EL-SALAHI'S WORK

- Mathaf, Arab Museum of Modern Art, Doha
- Museum for African Art, New York
- Museum of Modern Art, New York
- Tate Modern, London

DID YOU KNOW?

El-Salahi had a career as a diplomat and politician before being arrested and imprisoned for six months without charge in Sudan in 1975. He subsequently left his homeland, spending time in Qatar before eventually settling in England.

with a study of the darker aspects of urban society. Such unknown elements did not help him to attract interest in his homeland, and El-Salahi's work made little impact after he returned to Sudan in the late 1950s.

El-Salahi reacted to this indifference by travelling around the country, re-immersing himself in Sudanese culture. Following on from Osman Waqialla, who began an exploration of calligraphy as a purely artistic medium removed from sacred texts, as well as drawing on the North African Letterist movement Al-hurufiyya, El-Salahi worked tiny Arabic inscriptions into his paintings. El-Salahi's background in the Qur'anic school led to an interrogation of the forms of Arabic script and a particular focus on the spaces between and around the calligraphy. This led to a transformation of the lettering into forms that in turn stimulated the artist's imagination. The result of his experimentation was an extraordinary metamorphosis of traditional calligraphy, in which the fluid shapes came to define highly stylized figures, sometimes with the appearance of Islamic motifs such as the crescent, as in *Vision of the Tomb* (1965).

These poetic, highly expressive works often have complex narrative or allegorical meanings, exemplified by *Reborn Sounds of Childhood Dreams I* (1961–5), in which a collection of ghoulish characters looms ominously across the 2.6m (8½ft) square painting. The forms emphasize El-Salahi's hunger for new aesthetics, simultaneously evoking African masks, Arabic veils and surrealist elements, as well as showing a heightened awareness of human anatomy in the over-emphasized joints of the bodies. The paintings of this period, with their 'earthy' palette recalling the colours of Sudan's landscape, had a particular resonance for other African artists. El-Salahi became an important cultural figure, playing a key role in art festivals, which contributed significantly to the formation and recognition of pan-African art movements.

As inhabitants of a newly created country, the members of the Khartoum School sought to create a distinctly Sudanese aesthetic, but El-Salahi's work is also international in outlook, attempting to assess Sudan's new place in the world. While the Khartoum School was criticized both for its ethnocentrism and for holding exhibitions in traditionally bourgeois and 'Western' settings, El-Salahi's work was not confined to a narrow nationalism. His work of the early 1970s used a brightened palette and was increasingly experimental, with geometric designs conjuring figures and animals on the canvas. After his self-imposed political exile (to Qatar and then to England), he began to use a monochrome palette, through which he concentrated on compositional elements. However, he also continued to produce brighter images, such as *The Tree* series of 2001–9, in which increasingly geometric forms represent Sudan's native haraz tree.

In spite of these figurative elements, El-Salahi's Islamic faith is central to his work and he sees his art as a way of celebrating God's creation. His more recent works reflect his belief in the spiritual and therapeutic aspects of nature, as well as in the cultural heritage and mystical traditions of Islam. Throughout his career he has expressed a remarkably coherent set of values in work that has lost none of its formal invention.

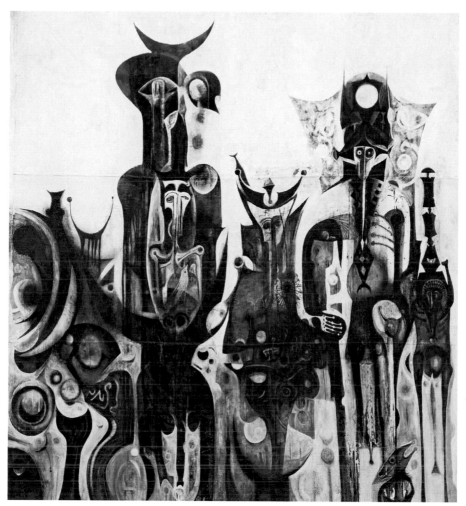

Reborn Sounds of Childhood Dreams I, oil and enamel on damouriya, 1961–5

MAX
ERNST

GERMAN
1891–1976

Max Ernst (born 1891, Brühl, near Cologne, Germany) created memorable collages and paintings, drawing imagery from his unconscious by procedures involving chance and free association. The power and originality of his art was essential to the development of Dada and Surrealism.

Ernst's father encouraged an interest in painting but pushed him into academic studies where he discovered the ideas of Sigmund Freud and Friedrich Nietzsche, and his early paintings reflect a variety of influences, from Vincent van Gogh to German Expressionism and Cubism. Ernst also became involved in the Cologne Dada branch in 1919 and exhibited with the Parisian group after settling there two years later.

His most important works of this period were dream-like paintings that recall collage, appropriating imagery from various sources. *Celebes* (1921) is based on a photograph of an African grain store, while *Pietà or Revolution by Night* (1923) borrows from both Giorgio de Chirico and Christian iconography. The resulting composition presents a compelling Freudian narrative about the artist and his father.

Ernst's subsequent work in the 1920s included the development of automatism through frottage and grattage. Inevitably, however, conscious decisions were made in order to produce paintings from these accidental marks, and examples such as *The Great Forest* (1927) clearly show the influence of German Romanticism.

WHERE TO SEE ERNST'S WORK

- Metropolitan Museum of Art, New York
- Peggy Guggenheim Collection, Venice
- Stedelijk Museum, Amsterdam
- Tate Modern, London
- Wadsworth Atheneum, Hartford, Connecticut
- Wallraf-Richartz-Museum, Cologne

DID YOU KNOW?

Ernst told a memorable account of a childhood memory of an imitation mahogany panel in his bedroom, out of which his father had magically conjured frightening creatures. This encouraged Ernst to examine the patterns of floorboards for inspiration and to rub them with lead on paper. In this way, the art method frottage was born.

The bird-like alter ego Loplop, emerged in *La Femme 100 têtes* (1929), a collage 'novel' derived from images in late 19th-century magazines, which, taken out of context, produce effects that are irrational, subversive and erotic. Loplop returned in collages and paintings during the 1930s, while more sinister avian creatures appeared in *The Barbarians* (1937), which reflects Ernst's pessimism during this period.

Exiled in New York during World War II, Ernst continued to experiment. He anticipated Jackson Pollock and dripped paint from a can, and borrowed from Óscar Domínguez the technique of decalcomania, producing the apocalyptic *Europe after the Rain II* (*c.*1940–42). Forever pluralistic, Ernst's late work also drew from the 16th century and pre-classical antiquity and he avoided tying himself to any particular movement.

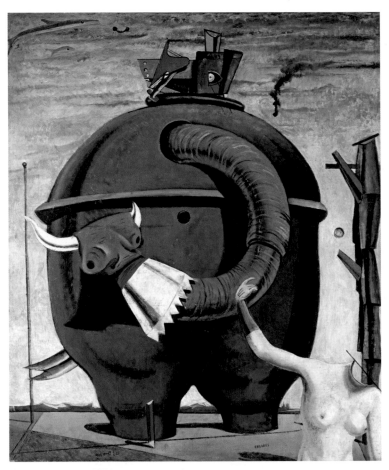

Celebes, oil on canvas, 1921

FREUD

LUCIAN
FREUD

BRITISH
1922–2011

Lucian Freud (born 1922, Berlin, Germany) was the most compelling British portrait painter of his age. Often viewed in strained poses and from unconventional viewpoints, his models rarely conformed to contemporary ideals of beauty. Freud's mastery of oil paint accentuated the texture and hue of their flesh, and the aim was not to gratify the eye. The artist's dispassionate approach to his subjects was all the more remarkable because the majority of them were members of his family, close friends or lovers.

The son of the architect Ernst Freud and the grandson of Sigmund Freud, Lucian moved with his family to Britain in 1932, and seven years later began his training in Dedham, Essex, at the East Anglian School of Painting and Drawing. His early work included elements of distortion or fantasy inspired by Continental artists such as George Grosz and the Surrealists. Even the English Neo-Romantic John Minton (whom Freud painted in 1952) exerted some influence. By the late 1940s, however, Freud was developing his own idiom.

Precise execution and smooth textures, combined with an air of malaise, characterize such paintings as *Interior in Paddington* (1951). The sense of alienation in this portrait of the photographer Harry Diamond is created by certain telling details – not just the man's clenched fist but also the raincoat that he wears indoors and the boy who stares menacingly up from the road outside.

WHERE TO SEE
FRUED'S WORK

- Art Institute of Chicago
- Astrup Fearnley Museet, Oslo
- Museo Thyssen-Bornemisza, Madrid
- Museum of Modern Art, New York
- Tate Britain, London
- Walker Art Gallery, Liverpool

DID YOU KNOW?

Freud was an enthusiastic patron of London restaurants. He had his favourites – one left his table empty with a burning candle when his death was announced – but that did not stop him throwing bread rolls if he thought that fellow diners were photographing him.

For all its distinction, *Interior in Paddington* does not show Freud's mature style, which began to appear in the late 1950s. Vigorous brushstrokes conveyed a stronger sense of the subject's skin tones and textures in a palette of greys, greens, violets and blues, while the dense paint took on a physical presence of its own. Freud varied his output by producing cityscapes and still lifes, as in *Two Plants* (1977–80), but the human figure, naked or clothed, remained his principal theme.

In his later years some of his compositions became highly ambitious, bringing together several people in tableaux that referred to Old Masters such as Jean-Antoine Watteau. Other works were small and intimate, including the singular portrait *Queen Elizabeth II*, which he made in 2000–01. Freud compared the difficulty of this task with that of a polar expedition.

While Freud's royal portrait retained some decorum, in general the artist showed a distinct preference for the nude, especially when representing people he knew well, whose transformation over time he could capture in his paintings. His subjects included his daughters, the performance artist Leigh Bowery and, from the late 1990s, his assistant the painter David Dawson. Freud's posthumous exhibition at the National Portrait Gallery, originally planned purely to coincide with the 2012 London Olympics, included the last, unfinished portrait of Dawson and his whippet Eli, entitled *Portrait of the Hound* (2011).

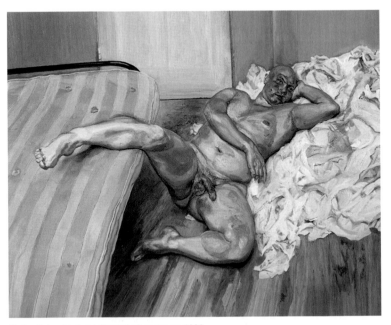

Nude with Leg Up (Leigh Bowery), oil on canvas, 1992

GIACOMETTI

ALBERTO
GIACOMETTI

SWISS
1901–66

Alberto Giacometti (born 1901, Borgonovo, Switzerland) was a Swiss sculptor who, despite the influences of Surrealism and Existentialist philosophy, remained highly independent and individualistic. He absorbed influences from ancient and African art, as well as European modernism, but created works that are unmistakably his own. As well as working in plaster, bronze and other sculptural materials, he painted striking portraits, especially in the last two decades of his career.

Giacometti was born into an artistic family – his father, Giovanni, was an accomplished Post-Impressionist painter – and he received a conventional training in Geneva and Paris. In France he started to study under Auguste Rodin's pupil Emile-Antoine Bourdelle in 1922 but quickly began to show a rebellious streak. African sculptures, Cubism and the work of Constantin Brâncuşi pushed him towards a high degree of abstraction, as in *Spoon Woman* (1926). Soon afterwards he also fell under the spell of Surrealism.

A lurid combination of sex and violence marks *Woman with Her Throat Cut* (1932), a piece that reclines on the floor like a mantrap. However, some of his Surrealist work cultivated a subtler, more enigmatic quality. In *Suspended Ball* (1930–1) a sphere hanging from a filament almost but not quite touches the crescent beneath, as if to evoke unfulfilled desire, while a weird sense of isolation characterizes a number of

WHERE TO SEE GIACOMETTI'S WORK

- Alberto Giacometti Foundation, Kunsthaus Zürich
- Albright-Knox Art Gallery, Buffalo, New York
- Art Institute of Chicago
- Solomon R Guggenheim Museum, New York
- Peggy Guggenheim Collection, Venice

DID YOU KNOW?

Giacometti had many famous friends. He met Marlene Dietrich in 1959 after which they saw each other on several other occasions, and he would regularly drink in Paris with the playwright Samuel Beckett. In 2013 a letter from Giacometti to Dietrich sold for more than $250,000 at auction.

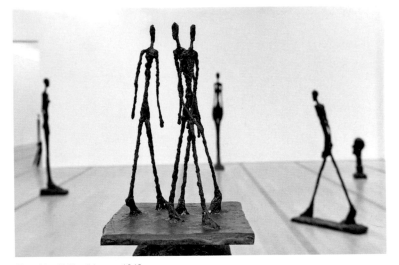

Three Men Walking II, bronze, 1949

works consisting of miniature platforms. With their barren landscapes and mysterious figures, they look like the weird progeny of a child's table-top game and a painting by Salvador Dalí.

The most nightmarish sculpture of all, *The Palace at 4am* (1932), presents disturbing forms such as a spine and a skeletal bird within the armature of a miniature house. It expresses succinctly Surrealism's desire to reveal the unconscious, yet by the mid-1930s Giacometti had been expelled from the movement for reviving a more traditional figurative style. The forms that he produced may have become relatively conventional, but Giacometti's portraits and still lifes of the late 1930s show a remarkable intensity. With their combination of a rigorous geometric structure and frenetic passages of brushwork, they anticipate the celebrated post-war paintings that include family portraits such as *The Artist's Mother* (1950).

Although Giacometti remained outside the Surrealist movement, in the immediate post-war years he produced distorted fragments of the human figure that do recall his earlier work. A disembodied arm extends into the void or a grotesque head, hanging inside a cage-like structure, projects aggressively into the viewer's space. In general, however, the sense of anguish was more controlled. Slender figures, standing or walking, convey a lonely mood even when they are presented in groups, as in *Three Men Walking II* (1949). Above all, their slender, attenuated proportions create an air of tremendous concentration, while the artist's expressive handling of material is exemplified by the puckered surface of *Walking Man I* (1960).

HEPWORTH
HOCKNEY
HOPPER
HUSAIN

BARBARA
HEPWORTH

BRITISH

1903–75

This British sculptor was one of the most distinctive abstract sculptors of the 20th century. Her work ranged from the intimate to the monumental and was often animated by a subtle interplay of solids and voids. She was particularly inspired by the landscape and megalithic sculpture of west Cornwall, where she settled in 1939.

Barbara Hepworth (born 1903, Wakefield, Yorkshire, UK) won scholarships at Leeds School of Art and the Royal College of Art in London in the early 1920s, when she developed an austere classical style. Her interest in Italian art led her and her husband, the sculptor John Skeaping, to begin 'direct carving', in reaction to the usual academic practice of transferring artists' models into stone. Her figures gradually became more abstracted and bulky, reflecting the outline of the blocks out of which they were made.

It was not until the 1930s, however, that Hepworth developed a fully abstract style akin to that of her second husband, Ben Nicholson. Together with Henry Moore, Hepworth and Nicholson were members of Unit One and participated in international exhibitions and periodicals devoted to non-figurative art. Hepworth's own works were characterized by a strongly geometric 'Constructive' quality, but they also included tapering and swelling forms inspired by the prehistoric menhirs and landscape of Cornwall. *Forms in Echelon* (1938) was even filmed in 1953 next to the Men-an-Tol megaliths in Cornwall and includes a block punctured by a circular hole.

WHERE TO SEE
HEPWORTH'S WORK

- Barbara Hepworth Museum and Sculpture Garden, St Ives
- The Hepworth Wakefield
- Leeds Art Gallery
- Tate Britain, London
- Yorkshire Sculpture Park, Wakefield

DID YOU KNOW?

For Hepworth, making art was an extension of herself and 'direct carving' came naturally to her. She once said, 'I know how to carve. No credit to me, I was just born like that.'

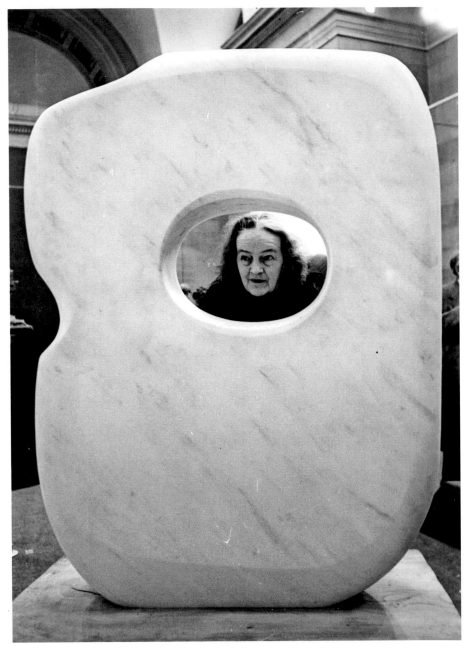

Hepworth with *Pierced Form*, marble, 1963

Hepworth's eventual move to Cornwall with her family was precipitated by the outbreak of World War II, although it was not for another ten years that she acquired the Trewyn Studio, which became the Barbara Hepworth Museum after her death in a house fire. Her new premises gave her space to create large-scale sculptures cast in bronze and other metals, but she also continued to work in marble, creating *Pierced Form* (1963). Some of the works created there are still on display in the garden outside the museum: one of them, *Four-Square Walk Through* (1966), is, as the name suggests, big enough to walk through. Others are more unassuming, articulated by contrasts of shape, texture and colour, as in the delicate sculpture *Spring* (1966), which evokes the seasonal cycles of the natural world.

The artist's remarkable statement 'In another age…I would simply have carved cathedrals' provides an insight into another of Hepworth's larger sculptures, *Cantate Domino* (1958). Here the religious ecstasy of Psalm 98 is not so much expressed as translated into an uplifting diamond-shaped composition.

Expressive abstract forms were, of course, Hepworth's stock-in-trade, but other references occasionally crept in, as in the aluminium *Winged Figure* (1963) that she created for the John Lewis department store in London. In this case, the sculpture is enlivened by the rods that span the space between the wings. As in so many of Hepworth's works, formal qualities – above all, the relationship between solid and void, interior and exterior – are pre-eminent.

Spring, bronze with strings, 1966

DAVID
HOCKNEY

BRITISH
BORN 1937

The instantly recognizable work of David Hockney (born 1937, Bradford, Yorkshire, UK) has given him a remarkable status among artists alive today. Exhibitions of his recent paintings have attracted large crowds, while he has made a graceful transition from *enfant terrible* to grand old man of British art.

Hockney spent his early years in Yorkshire, the county whose landscape has informed so much of his late work. It was, however, in London as a student at the Royal College of Art in the early 1960s that he made his name among a group of nascent Pop artists including R B Kitaj, Patrick Caulfield and Allen Jones. His early works, such as *We Two Boys Together Clinging* (1961), combined stylistic and technical experimentation with audacious, erotic subjects.

It was, however, in California, to which Hockney first moved in 1964, that he created his most memorable images of 1960s hedonism. Acrylic paintings of outdoor swimming pools, for example, *A Bigger Splash* (1967), combine bold graphic designs with a brilliant palette, while the naked men in other pictures reflect the changing attitudes to homosexuality at this time.

Despite his subversive tendencies, Hockney was no iconoclast. His group portrait *Mr and Mrs Clark and Percy* (1970–1) reverses the gender stereotypes of Thomas Gainsborough's *Mr and Mrs Andrews* (*c*.1750) – Hockney shows the man seated and

WHERE TO SEE
HOCKNEY'S WORK

- Cartwright Hall Art Gallery, Bradford
- Los Angeles County Museum of Art
- Louisiana Museum of Modern Art, Humlebæk, Denmark
- Salts Mill, Saltaire, Bradford
- Tate Britain, London

DID YOU KNOW?

Hockney has produced what are probably the largest paintings ever made in the open air. *Bigger Trees near Warter* (2007) is more than 12m (40ft wide). It consists of 50 canvases, which Hockney painted in the open air, allegedly while wearing multiple coats and heated gloves.

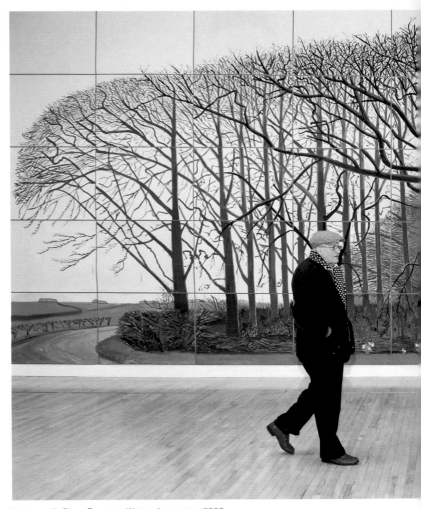

Hockney with *Bigger Trees near Warter,* oil on canvas, 2007

the woman standing – but still pays tribute to his 18th-century predecessor, just as his later works draw on the traditions of the English landscape.

Hockney is also innovative with the camera, not least in his photocollages. With their multiple viewpoints, partly influenced by the Cubism of Picasso and Braque, they offer an alternative to the conventional photography that had formed the basis of much of his earlier work. Subsequent developments in technology – from colour photocopiers to high-definition digital videos and the iPad – offered Hockney

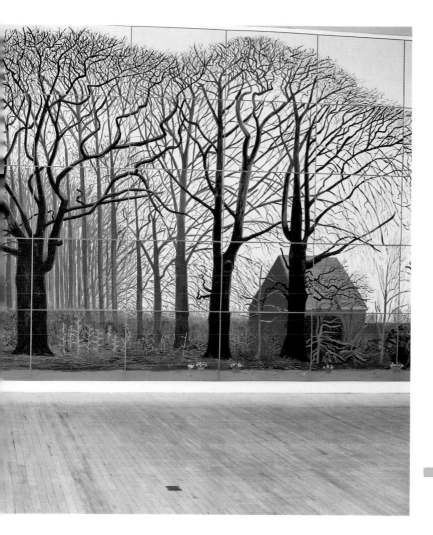

other opportunities to convey his experience of the natural world. But he has never abandoned conventional painting, as his watercolours and canvases made in the open air in the east Yorkshire landscape, such as the monumental *Bigger Trees Near Warter* (2007), have demonstrated for over 15 years. He also made a close study of the optical innovations exploited by the Old Masters, leading to the publication of *Secret Knowledge* (2001), a book that argued for a more widespread use of the camera obscura in Western art than has generally been accepted by art historians.

EDWARD
HOPPER

AMERICAN
1882–1967

Edward Hopper's wistful paintings of American life are among the most memorable images of the 20th century. Their artful compositions and narrative qualities encourage comparisons with the cinema, and celebrated film-makers have acknowledged direct inspiration from Hopper's work.

Hopper (born 1882, Nyack, New York, USA) came to New York City to study commercial illustration and painting with the encouragement of his family. He subsequently worked for an advertising agency before embarking in 1906 on a tour of Europe, where he was particularly impressed by the works of Edouard Manet and the French Impressionists. This experience spurred him to develop his skills as a painter, although he spent 16 years working as a freelance commercial artist before he began to achieve real critical success from 1924 onwards.

House by the Railroad (1925), which was the first work to be acquired by the Museum of Modern Art in New York, exemplifies Hopper's melancholy appeal. A solitary mansion, marooned by the tracks with its blinds drawn, is given an almost anthropomorphic quality. A sense of profound loneliness also pervades the paintings that Hopper made on the Massachusetts coast, such as *Cape Cod Sunset* (1934), though generally Hopper concentrated on presenting the alienating effects of modern city life.

WHERE TO SEE HOPPER'S WORK

- Art Institute of Chicago
- Museo Thyssen-Bornemisza, Madrid
- Museum of Modern Art, New York
- Whitney Museum of American Art, New York
- Yale University Art Gallery, New Haven, Connecticut

DID YOU KNOW?

Film director Alfred Hitchcock acknowledged that *House by the Railroad* (1925) was the inspiration for the motel in *Psycho* (1960), while the German director Wim Wenders stated that viewers of Hopper's paintings enjoy a kind of cinematic experience, imagining a 'before' and 'after' that put the still scene into motion.

American life was the subject of Hopper's paintings and his compositions focus on typical surroundings with minimal superfluous details. Whether at work or play, Hopper's figures often appear isolated from one other and oblivious of their surroundings. This is especially true of such voyeuristic nocturnal pictures as *Nighthawks* (1942), which simultaneously illustrates Hopper's characteristic use of light and shadow on the canvas. In the painting the customers of a brightly illuminated all-night diner are seen through an enormous plate-glass window but take no interest in the empty streets around them, or even in each other.

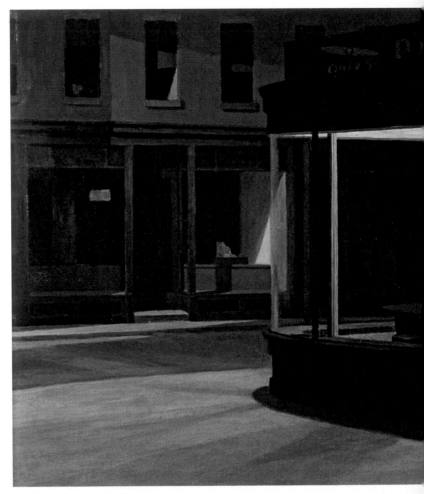

Nighthawks, oil on canvas, 1942

Despite this detachment, Hopper's paintings also offer a glimpse into his personal life, since many of the women in them were modelled on his wife Jo, whom he married in 1924. In *Western Motel* (1957), the artist's wife and car are given an almost equal status, with the Buick positioned so that it seems to erupt from the woman's chest.

In contrast, *Morning in a City* (1944) is a more intimate picture, with the nude figure standing bathed in light and gazing towards the window on the left. This sense of reverie is typical of his art, which, in his own words, was concerned with 'the outward expression of an inner life'.

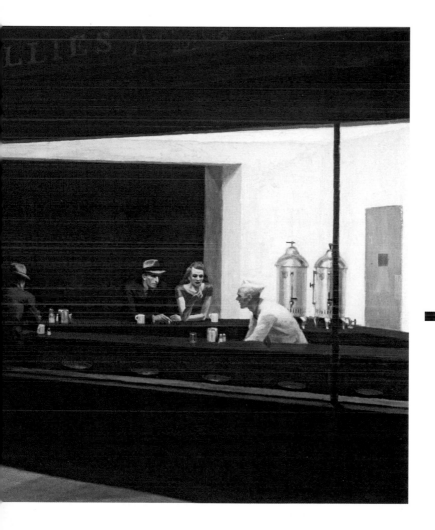

MAQBOOL FIDA
HUSAIN

INDIAN
1915–2011

Known as the Pablo Picasso of Indian art, Maqbool Fida Husain (born 1915, Pandharpur, India) was an extremely prolific and inventive painter. Indeed, he was sometimes too imaginative for his own good, and his representations of Hindu religious stories attracted so much criticism in his home country that he ended his life in exile.

Husain spent much of his early life in Indore where, as an impoverished Muslim in a largely Hindu society, he had little formal education. As a young man, he painted cinema posters in Bombay, where he studied briefly at the Sir Jamsetjee Jeejeebhoy School of Art, and in 1947 he joined the Bombay Progressive Artists' Group. Like his colleagues Francis Newton Souza and Syed Haider Raza, Husain rapidly achieved international renown. Unlike them, he stayed in Mumbai for most of his life.

While clearly influenced by Cubism, Husain's monumental paintings had a strong popular appeal, with vivid colours and subjects ranging from horses and film stars to historical scenes. By the mid-1950s he was winning national honours, and he won an award at the Berlin Film Festival for his first film, *Through the Eyes of a Painter* (1967). Four years later he and Picasso were the principal artists at the São Paolo Biennale.

In the mid-1970s Husain attracted criticism for representing Prime Minister Indira Gandhi as the goddess Durga. He had a particular penchant for depicting strong women, from his images of Kerala's Kalyani Kutty and Mother Teresa to the Bollywood star

WHERE TO SEE
HUSAIN'S WORK

- The Chester and Davida Herwitz Collection, Peabody Essex Museum, Salem, Massachusetts
- National Gallery of Modern Art, Mumbai
- National Gallery of Modern Art, New Delhi
- National Museum of Islamic Art, Doha

DID YOU KNOW?

Between 1986 and 1992, Husain was a member of the upper house of the Indian parliament. He was nominated by Prime Minister Rajiv Gandhi and spent his time there sketching his colleagues.

Madhuri Dixit, who appeared in his unsuccessful film *Gaja Gamini* (2000). It was a series of 30-year-old paintings of the Hindu goddesses Durga, Lakshmi and Saraswati 'clothed only by sky', together with a recent nude painting of *Bharatmata (Mother India)* (2006), that sparked off ferocious demonstrations and Husain's exile in 2006.

Husain became a Qatari citizen in 2010 and continued to jet around the world incessantly. He was drawn in particular to New York and London, where he died in 2011. His individual works fetched in excess of a million dollars at auction, and at his death he was working on an ambitious series of paintings commissioned by the steel magnate Lakshmi Mittal. Their subject was nothing less than 'Indian civilization'.

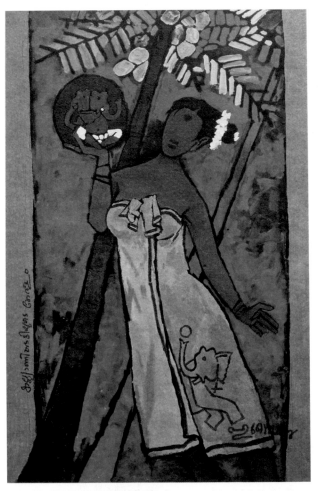

Kalyani Kutty, oil on canvas, date unknown

INDIANA

ROBERT
▮NDIANA

AMERICAN
BORN 1928

Robert Indiana (born Robert Clark, 1928, New Castle, Indiana, USA) is a leading figure of American Pop art, whose bold graphic designs, often incorporating words such as 'Love' and 'Hope', have achieved international renown. In 1963 he declared that Pop art had replaced Abstract Expressionism in 'the eternal What-Is-New-in-American-Painting shows' and he gave it 'ten years perhaps'.

Following military service, Indiana entered the Art Institute of Chicago in 1949. After studying in Maine and Edinburgh, he settled in New York where he produced sculptures from rough pieces of wood embellished with found objects such as metal wheels, as well as stencilled letters and coloured lines reminiscent of street signs. *Zig* (1960) also manages to evoke the shape of classical Greek herms, even though the depiction of the male anatomy is reductive, to say the least. In this way, Indiana's work combined references to everyday life, high culture and the scatological.

During the 1960s Indiana was a key member of the Pop art movement, participating in the seminal *New Realists* show of 1962 at the Sidney Janis Gallery. Although resembling dials, signs and the other ubiquitous symbols of Pop, Indiana's crisply painted compositions also reflected the hard-edged abstraction developed by his friend Ellsworth Kelly. As Indiana put it, 'Pop is either hard-core or hard-edge. I am hard-edge Pop.'

WHERE TO SEE INDIANA'S WORK

- Indianapolis Museum of Art
- Miami University Art Museum, Oxford, Ohio
- Museum of Modern Art, New York
- Whitney Museum of American Art, New York

DID YOU KNOW?

Indiana lived in more than 20 different houses with his parents, an experience reflected in *Mother and Father* (1963). Eventually, Indiana's father left with another woman and his mother got into her car and scoured the countryside with a '38 revolver the evening that he left. Indiana's painting presents the couple 'totally unaware of the sad trip ahead'.

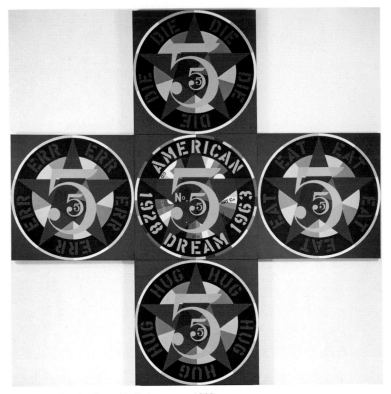

The Demuth American Dream No. 5, oil on canvas, 1963

The precise technique and stencilling of images such as *Eat/Die* (1962) masked their personal significance (referring to his parents' deaths), while others allude directly to the painting *I Saw the Figure 5 in Gold* (1928), by Charles Demuth, which inspired Indiana to incorporate the same number into such works as *The Demuth American Dream No. 5* (1963). The obscure numerology is a classic example of an esoteric meaning lurking behind a clear, graphic image. To some extent, the same could be said of the painting *Love* (1966), which has been reproduced in numerous formats, including large metal sculptures and a postage stamp. For all its apparent simplicity, the word, both a noun and a verb, an actual experience and an exhortation, is ambivalent. It is both a celebration of love and a reflection of the politics of the period.

Indiana remains an articulate and perceptive figure, responding to the attack on the World Trade Center in New York with *Afghanistan* (2001), and the American-led invasion of Iraq with the *Peace* series (2003–4). Few artists have represented more powerfully the optimism, naivety and perils embodied in the American Dream.

JOHNS

JASPER
JOHNS

AMERICAN
BORN 1930

The paradox of Jasper Johns's work is that it is instantly recognizable despite being based on the repetition of impersonal signs. His rejection of traditional concepts of artistic creation attracted the label 'Neo-Dada' in the early 1960s, when his repetition of banal, ubiquitous imagery played a vital role in the formation of Pop art.

Jasper Johns (born 1930, Augusta, Georgia, USA) grew up and studied in South Carolina before serving in the Korean War (1950–53). On his return to America in 1953, he briefly attended the City College in New York. More important, however, were his friendships and collaborations with fellow artist Robert Rauschenberg, the composer John Cage and the dancer Merce Cunningham.

Johns's artistic development was rapid. He destroyed his early assemblages, which had been inspired by Kurt Schwitters and Joseph Cornell, and, like Rauschenberg, repudiated the subjectivity of Abstract Expressionism. In 1954 he was even blessed with a vision – a dream of himself painting a picture of a large American flag. Works including *Three Flags* (1958) followed, using the medium of encaustic (hot wax), with which he also made images of targets and stencilled numbers and alphabets.

While the signs themselves are easily understood, Johns's manipulation of them was deliberately ambiguous. In some of his works, a flat, painted target was juxtaposed with plaster casts of faces, confounding the relationship between viewer and viewed, and

WHERE TO SEE JOHNS'S WORK
- Kunstmuseum, Basel
- Museum Ludwig, Cologne
- Museum of Modern Art, New York
- Neue Galerie, Aachen

DID YOU KNOW?
In 1980 the Whitney Museum of American Art in New York paid $1 million for *Three Flags* (1958). At the time it was the highest price ever paid for a living artist's work, though by the end of the decade his work would fetch up to 17 times that figure.

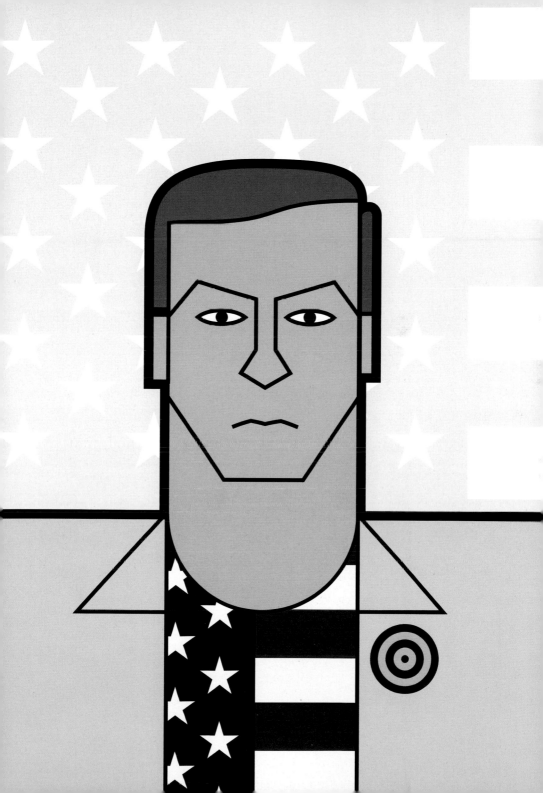

mixing up different media and textures. Johns was particularly interested in combining casting with less mechanical procedures, as in *Painted Bronze* (1960), a sculpture of two beer cans. This work superficially resembles Andy Warhol's slightly later soup tins and other pieces of consumer imagery, but is technically and conceptually more sophisticated.

Around this time, Johns also started making prints, often reusing his own images, almost as if they were ready-mades. This interest in replication also extended, in true Pop style, to incorporating reproductions of the *Mona Lisa* (*c.*1503–6) and other Old Master works in his paintings. However, it did not prevent him from engaging in formal experimentation, as in the striking cross-hatching pictures made in the 1970s and 1980s. These highly structured, abstract compositions are exemplified by *Between the Clock and the Bed* (1981), which shares a title with one of Edvard Munch's self-portraits, even though it does not resemble it in any way.

This work expresses two of Johns's most fundamental concerns: the relationship between word and image, and the concept of artistic originality. These themes have remained recurrent features of Johns's career, and appeared with some panache in the *Regrets* series (2013), recently exhibited at New York's Museum of Modern Art. These are highly abstracted pictures, with their title rubber-stamped on the canvas, yet they all refer recognizably to the desperate pose of the artist Lucian Freud in a photograph owned by his fellow painter Francis Bacon. The chain of allusions – the spectre of one work inside another – is essential to Johns's approach, and to the artistry that has made him such an original figure since the 1950s.

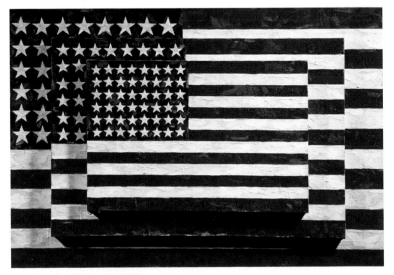

Three Flags, encaustic collage, 1958

KAHLO

KANDINSKY

KLEE

KUSAMA

FRIDA
KAHLO

MEXICAN
1907–54

The great achievement of Frida Kahlo (born 1907, Coyoacán, near Mexico City, Mexico) was to transform her persona into a rich iconography, in which her own features are combined with motifs drawn from her life as well as from the complex heritage of her native Mexico. Like her husband, the mural painter Diego Rivera, Kahlo was a committed communist: Marx and Stalin make appearances in *Marxism Will Give Health to the Sick* (1954), while a number of works contain bleak industrial landscapes that are clearly identified with American capitalism.

Born into a middle-class family, Kahlo suffered a serious accident at the age of 18, when a tram crashed into a bus that she was riding in Mexico City. She never fully recovered and underwent more than 30 operations during the course of her life. In the months following the accident she began to paint, producing a year later her first self-portrait, in which her elongated neck and hands suggest the elegance of an Italian Renaissance painting.

Gradually, Kahlo developed a more distinctly Mexican identity. In *Self-Portrait on the Borderline between Mexico and the United States* (1932) she represented herself clasping the national flag next to a pre-Columbian pyramid. Later paintings juxtaposed her with a monkey, parrot or tropical flower or adorned her with a Mexican lace headdress.

WHERE TO SEE KAHLO'S WORK

- Museo de Arte Moderno, Conaculta-INBA, Mexico City
- Museo Dolores Olmedo Patiño, Mexico City
- Museo Frida Kahlo, Mexico City
- Museum of Modern Art, New York
- National Museum of Women in the Arts, Washington, DC

DID YOU KNOW?

Kahlo and Rivera had a tumultuous relationship, marrying, divorcing, and then remarrying a year later. They both had extramarital affairs, including Rivera's affair with Kahlo's younger sister and Kahlo's affair with the prominent Communist Leon Trotsky, which many believe was an act of revenge for Rivera and her sister's betrayal.

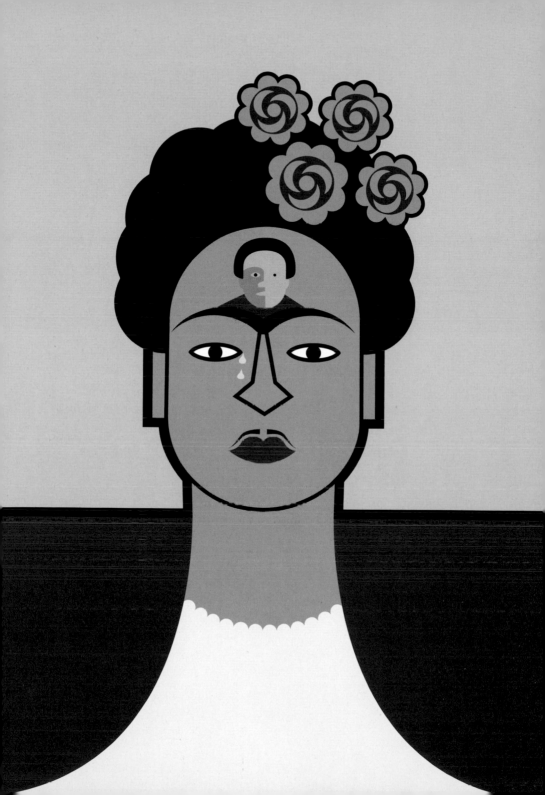

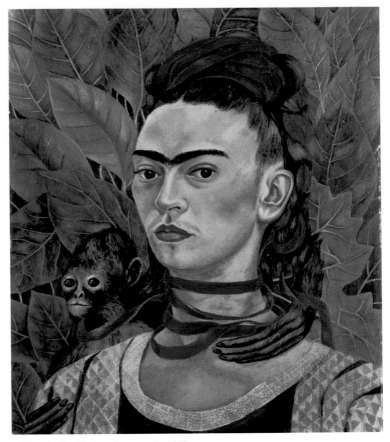

Self-Portrait with a Monkey, oil on masonite, 1940

Kahlo also sometimes depicted herself with the face of Rivera, whom she married in 1929, superimposed on her forehead, his shoulders perched neatly on her own luxurious eyebrows. Other images refer to the darker and tragic aspects of their marriage. *Self-Portrait with Cropped Hair* (1940) can be regarded as exploring an alternative, androgynous identity but, with its inscription from a Mexican song, 'Look, if I loved you it was because of your hair. Now that you are without hair, I don't love you anymore', it also represented Kahlo's reaction to her recent divorce from Rivera. They were remarried the following year.

When Kahlo died in 1954, she was widely mourned in Mexico, but it is only since the 1970s that she has achieved a high international status. Her work has been sought by celebrity collectors such as Madonna, and in 2002 she was the subject of the memorable film, *Frida* directed by Julie Taymor and starring Salma Hayek.

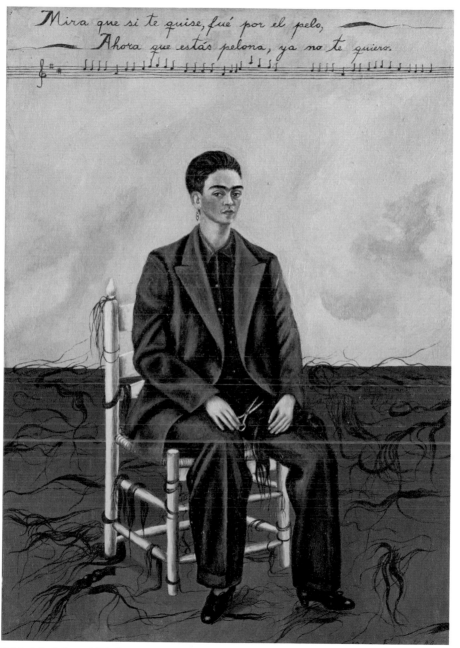

Self-Portrait with Cropped Hair, oil on canvas, 1940

WASSILY
KANDINSKY

RUSSIAN
1866–1944

A pioneer of abstract art, Wassily Kandinsky (born 1866, Moscow, Russia) made a bold attempt to redefine the function of painting. For him, art's purpose was to express an intense spiritual reality that lay beyond the world of external appearances. As well as being influenced by the esoteric philosophy known as Theosophy, he was also inspired to create art that was analogous to music, the most abstract and non-representational of art forms.

Although Kandinsky was brought up mostly in Odessa, he had a particular affinity for the 'fairy-tale' qualities of Moscow, where he was born. He was deeply influenced by the immaterial style and subject-matter of Russian icons and folk art, but it was an exhibition of Impressionism held in Moscow in 1896 that played the most important role in making Kandinsky reject the realism of 19th-century Russian painting.

The coloured patches of Impressionism can be seen in many of the highly expressive and stylized landscapes that Kandinsky produced following his move to Munich in 1896. It was while teaching in 1902 at the Phalanx School in Munich that he met his lover, the Expressionist painter Gabriele Münter, with whom he travelled extensively over the next few years. Eventually, they began to spend much of their time in the Bavarian town of Murnau, where Münter bought a house in 1909 and both artists produced luminous landscapes, partly influenced by Matisse and the Fauves.

WHERE TO SEE KANDINSKY'S WORK

- Centre Georges Pompidou, Paris
- Solomon R Guggenheim Museum, New York
- Städtische Galerie im Lenbachhaus, Munich
- State Russian Museum, St Petersburg
- The State Tretyakov Gallery, Moscow

DID YOU KNOW?

Kandinsky described how in 1896 a performance of Richard Wagner's opera *Lohengrin* made him see 'wild, almost crazy lines' and colours standing before his eyes. As he put it, 'It became…quite clear to me that art in general was far more powerful than I had thought, and on the other hand, that painting could develop just such powers as music possesses.'

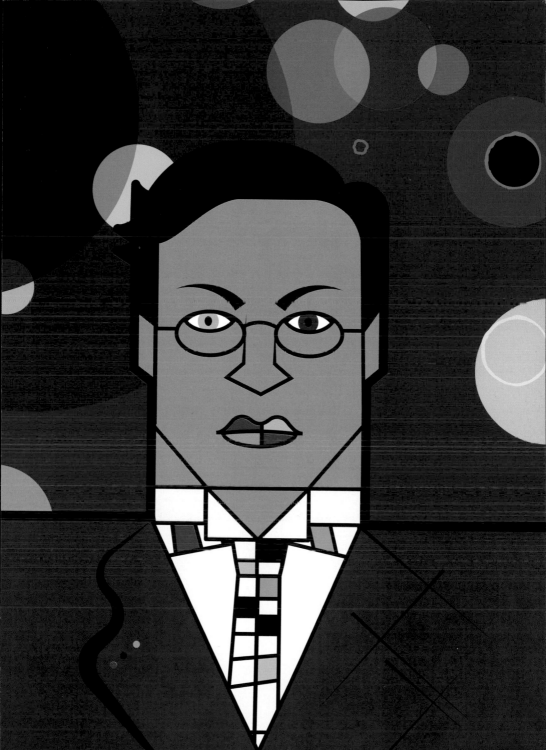

Gradually, Kandinsky's work became more highly abstracted, though esoteric subjects, such as St George killing the dragon, can be made out in *Painting with White Border* (1913) and other works of this period. By the end of 1913 many of Kandinsky's paintings were completely non-figurative, with dynamic patterns of interacting colours and lines of different lengths, widths and textures. In his book *Concerning the Spiritual in Art* (1912) Kandinsky described how he aimed to create an inner 'vibration' in the viewer, and many of his pictures were given musical titles such as 'Improvisation' and 'Composition'. This fertile period also included collaboration with Franz Marc and the artists' group *Der Blaue Reiter* (The Blue Rider), the name of which refers to a recurring motif that Kandinsky used to indicate his movement towards abstraction.

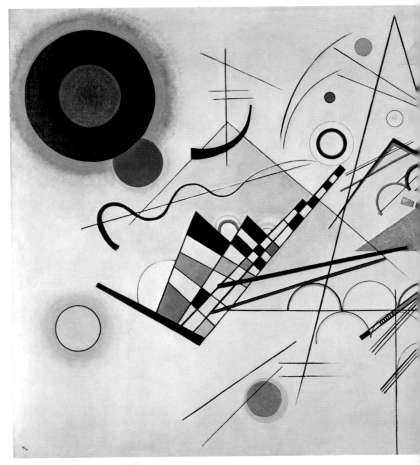

Composition 8, oil on canvas, 1923

The onset of World War I forced Kandinsky to return to Russia, but after the 1917 October Revolution he returned to Germany in 1921. In the following year he began an association with the Bauhaus that lasted until its closure in 1933. The rational approach of the Bauhaus complemented the influence of the Russian Constructivists, whom Kandinsky had encountered in Moscow. As a consequence, his own work became crisper and more geometric with relatively muted colours, as in *Composition 8* (1923), though mystical and spiritual preoccupations remained important.

After the Nazis dissolved the Bauhaus, Kandinsky moved to France, where in 1941 he refused an invitation to emigrate to the United States. He continued to work until he became too ill to do so just a few months before his death.

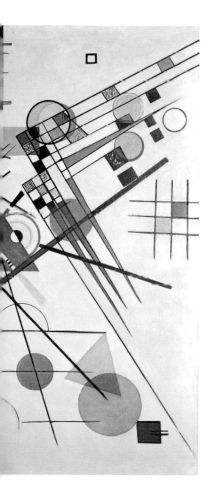

PAUL
KLEE

GERMAN
1879–1940

Paul Klee (born 1879, Münchenbuchsee, near Bern, Switzerland) was one of the most productive painters of the 20th century, whose work combines a keen wit with vibrant colours and a rigorous formal approach. He absorbed influences from modern movements that others might have regarded as incompatible but, despite his stylistic acquisitiveness, he preserved a unique artistic identity.

Klee was given his father's German nationality and later studied in Munich, where eventually he became close to Wassily Kandinsky and *Der Blaue Reiter* (The Blue Rider) group. In the Bavarian capital he was stimulated by an exhibition of Pablo Picasso's work in 1910, but even more important was his meeting in Paris with Robert Delaunay a couple of years later.

Klee's own use of colour was inspired not only by Delaunay but also by a trip to Tunisia in 1914, after which he declared that 'Colour and I are one. I am a painter.' This epiphany led in the following years to brilliant watercolours like *Three Houses and a Bridge* (1922) dominated by abstract coloured planes. During this period he also produced some satirical images such as *Memorial to the Kaiser* (1920), which exemplifies his oil-transfer technique, an innovation that involved tracing a drawing over a sheet of painted paper so that the imprint of the drawing would appear on the blank sheet below.

WHERE TO SEE KLEE'S WORK

- Kunstmuseum, Basel
- Zentrum Paul Klee, Berlin
- Kunstmuseum, Bern
- Sprengel Museum, Hannover
- Metropolitan Museum of Art, New York
- Museum of Modern Art, New York
- Des Moines Art Center, Iowa

DID YOU KNOW?

Klee came from a musical family and made his living as a professional violinist around the turn of the 20th century. His continuing interest in music can be seen in various works, including the remarkable pointillist paintings of the early 1930s. Here the complex arrangements of form and colour create a visual equivalent to polyphonic musical composition.

After the end of World War I Klee, briefly involved in a left-wing uprising, escaped the inevitable backlash by joining his parents in Bern. Within two years, he was given an influential Bauhaus teaching post, which he kept until 1931. Many works from this period are grids of colour that seem closely aligned with Bauhaus Constructivism, while others are governed by disciplined transitions between areas of red and green; yet the effect is never forced or schematic. Although some of the 'colour gradations' are highly abstracted, Klee also produced strange aquatic compositions demonstrating a wilder poetic imagination, which brought him to the attention of the Surrealists. They praised Klee's childlike intuition and included him in their exhibition of 1925.

Following Klee's move in 1931 to Düsseldorf, where he had a new teaching position, Klee produced pointillist paintings such as *Polyphony* (1932), combining intense colours with a mosaic-like density. It was at this exciting point in his career that Klee was struck by two calamities: the rise of Hitler in 1933 and, soon afterwards, the onset of a degenerative illness, which was to kill him in 1940. Having lost his job, Klee moved with his family to Bern, where, despite his desperate circumstances, he continued to work. Darkness dominates images such as *Catastrophe in a Dream* (1939), but other paintings such as *Still Glows* (1939) display the luminosity of his earlier work.

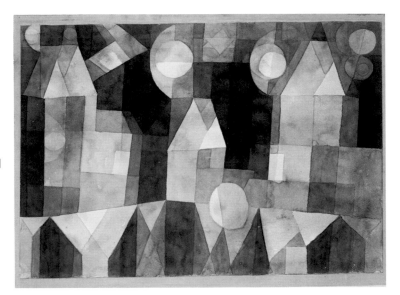

Three Houses and a Bridge, Watercolour and pencil on paper, 1922

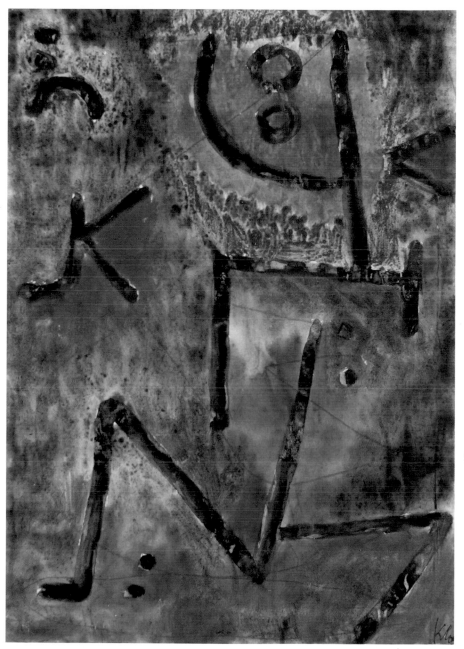

Still Glows, watercolour and pencil on paper, 1939

YAYOI
KUSAMA

JAPANESE

BORN 1929

The Japanese artist Yayoi Kusama (born 1929, Matsumoto, Japan) drew on her long experience of mental illness in order to create the provocative sculptures, zany installations and polka-dot paintings for which she became famous. She described how throughout her life she felt 'imprisoned' by intense sensations of 'nature, the universe, people and blood and flowers', and channelled this struggle into her art.

Despite a lack of support from her parents, Kusama compensated for the unavailability of canvases in the 1940s by using pieces of sacking from her family's plant nursery business before starting her training at the Kyoto Art Academy. She rejected the school's traditional teaching and was filling her watercolours with polka dots by the early 1950s. These works provided a form of escape for Kusama and an opportunity to express her psychotic experiences and hallucinations, in which the things around her seemed to replicate themselves ceaselessly.

Leaving the oppressive conservatism of Japan, Kusama arrived in the United States in 1957, when she began to produce the large abstract pictures known as *Infinity Net* paintings. These delicate, minimalist compositions of tiny dots in varying shades of white were intended to be a metaphor for the overwhelming endlessness of the cosmos. In New York she also made the acquaintance of key figures such as Andy Warhol, contributing to exhibitions of Pop art in the 1960s with a variety of subverted

WHERE TO SEE
KUSAMA'S WORK

- Lille Europe railway station
- Los Angeles County Museum of Art
- National Museum of Modern Art, Tokyo
- Tate Modern, London
- Walker Art Center, Minneapolis, Minnesota

DID YOU KNOW?

By the end of the 1970s Kusama had moved permanently into a psychiatric facility in Tokyo, continuing her art production in a studio close to the hospital. She also provided insights into her inner life through a series of autobiographical novels, which culminated in *The Psychological Hospital of Ants* (1994).

everyday objects. These included sofas, cabinets, step-ladders and high heels, covered with stuffed cloth penises as a parody of phallic power.

These so-called *Accumulation* sculptures were followed later in the 1960s by naked happenings, tapping into the spirit of counter-culture that seized the USA during the Vietnam War. Kusama strongly identified with the emerging hippie scene, painting herself and fellow participants with spots in a series of *Self Obliteration* and *Anatomic Explosion* happenings, as well as in racier, ticketed orgy parties. Out of these events stemmed the critically acclaimed film *Kusama's Self-Obliteration (no.82)* (1967), with music from rock band The Group Image.

Kusama was astute at commercializing her work and also achieved success as a fashion designer under the label Kusama Fashion Institute, through which she sold polka-dot pieces, some with daringly risqué cut-outs. However, as she continued to court controversy, her reputation in the USA began to wane and in 1973 she returned to Japan. There she produced immense vegetal sculptures such as *Pumpkin* (*c.*1994), sometimes for public spaces; dazzling paintings crowded with constellations of eyes; more *Dots Obsession* works; and *Infinity Room* installations, in which tiny lights and mirrors create a magical, never-ending vista. In her later years Kusama commanded huge prices for her work, which could fetch in excess of 5 million dollars at auction.

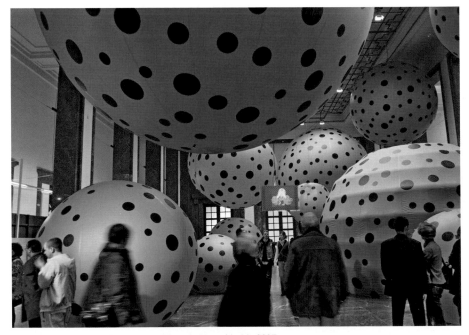

Dots Obsession, mixed media installation at Haus der Kunst, Munich, 2007

LÉGER
LICHTENSTEIN

FERNAND LÉGER

FRENCH
1881–1955

Fernand Léger (born 1881, Argentan, Normandy, France) was an important pioneer of Cubism, who also made a distinctive contribution to the development of abstract art in France. His most impressive achievements are, nonetheless, his figurative pictures, many of which express his left-wing convictions through monumental images of workers.

Léger was apprenticed to an architect before training at the École des arts décoratifs in Paris. In his youth, Léger absorbed a variety of influences, including Impressionism, Neo-Impressionism and Fauvism, although he later destroyed much of his early work. By 1909 he was simplifying the human figure in a manner that recalls the work of Paul Cézanne. This tendency made him receptive to the innovations of Pablo Picasso and Georges Braque, and in *The Smokers* (1911–12) even puffs of smoke are transformed into Cubist planes. By 1913 cylinders with strong outlines and primary colours were dominant. While some of these images have a figurative element, others, notably *Contrast of Forms* (1913), are purely abstract, with a dynamic quality intended to convey the energy of modern life.

For all his formal experimentation, Léger was an artist who engaged profoundly with the world around him. At the front in World War I, Léger made some memorable drawings of his fellow soldiers, and he returned to Paris determined to engage with

WHERE TO SEE LÉGER'S WORK

- Centre Georges Pompidou, Paris
- Musée National Fernand Léger, Biot
- Museum of Modern Art, New York
- Philadelphia Museum of Art
- Rijksmuseum Kröller-Müller, Otterlo
- Solomon R Guggenheim Museum, New York

DID YOU KNOW?

Léger's film, *Ballet mécanique* (1924) contained rhythmic sequences of moving machinery, human forms, domestic objects and abstract shapes. It was set to music by George Antheil with interesting effects such as the sounds of propellers, which were actually made by inserting pieces of wood or leather into electric fans.

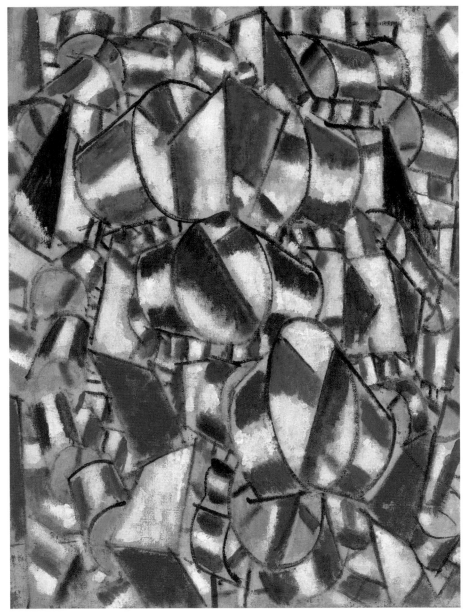

Contrast of Forms, oil on canvas, 1913

modern and popular themes. The visual impact of advertising inspired *The City* (1919), while other canvases depicted propellers and other machine parts. Even the human figure became shiny and metallic, as in the monumental *Three Women (Le Grand Déjeuner)* (1921), though here the three nudes also evoke the classical tradition in Western painting.

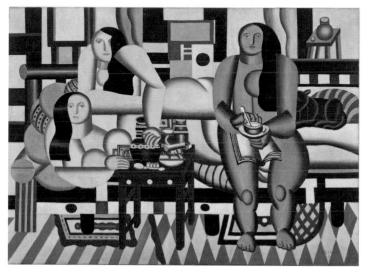

Three Women (Le Grand Déjeuner), oil on canvas, 1921

Léger's commitment to collectivist principles led him to take up some prominent public commissions for murals in Paris. In 1925 he collaborated at the *Exposition internationale des arts décoratifs et industriels modernes* with Robert Delaunay and Amédée Ozenfant, whose Purist ideas on the integration of art and architecture influenced Léger at this time. This project was followed 12 years later by a mural depicting the industrial and natural worlds at the Palais de la découverte in the *Exposition internationale des arts et techniques dans la vie moderne*. Here he collaborated with a team of his students, in a manner more reminiscent of a Renaissance workshop than a workers' cooperative.

After spending World War II in the United States, Léger returned to France in 1946, where he produced pictures with a strong political element. These included *Leisure (Homage to Jacques-Louis David)* (1948–9) and other striking paintings of the common man. He exhibited some of these in a Renault factory canteen, to a mixed reception. Ultimately, his work represented the people in an idiom that appealed to the elite.

ROY
LICHTENSTEIN

AMERICAN
1923–97

Roy Lichtenstein's paintings, inspired by the subjects and production methods of comic strips and advertisements, were essential to the development of American Pop art. Although he continued to absorb new image sources, which were subjected to his trademark style, his work was remarkably consistent from the 1960s onwards.

Lichtenstein (born 1923, New York, USA), first studied art as a teenager in short courses in his native New York, before entering Ohio State University in Columbus in 1940. In Ohio he was influenced by Hoyt L Sherman, an artist working in a Fauve style who was interested in the psychology of perception. After military service, Lichtenstein began to appropriate a wide range of sources, from Pablo Picasso and Abstract Expressionism to 19th-century American painting. His works were described by visual artist Letty Lou Eisenhauer as 'small squares that gave the impression of mushy fields'.

It was not until the early 1960s that he developed his characteristic idiom, mimicking the coloured Ben-Day dots of comic strips. At first, these paintings were of cartoon characters such as Mickey Mouse, but he soon moved on to create Magna-acrylic paintings of war and romance, which were at once slick and histrionic. Using speech bubbles, he created melodramatic narratives about a young woman and her artist boyfriend Brad – Lichtenstein's alter ego. Meanwhile *Whaam!* (1963) reduced a moment of violence to a mere exclamation, trivializing its subject (a battle

WHERE TO SEE
LICHTENSTEIN'S WORK
- Art Institute of Chicago
- Kunstmuseum, Basel
- Tate Modern, London
- Walker Art Center, Minneapolis, Minnesota
- National Gallery of Art, Washington, DC

DID YOU KNOW?
It was Lichtenstein's son who drove him to adopt his best-known style of painting. Looking through a Mickey Mouse comic book, one of his sons pointed to a picture saying, 'I bet you can't paint as good as that,' and so Lichtenstein was compelled to respond.

Look Mickey, oil on canvas, 1961

between World War II fighter planes), while also creating a monumental effect, in which the image was blown up to the scale of an altarpiece or history painting. Lichtenstein's delight in playing with the conventions of high art led to some memorable pastiches, usually of modern masters. During the 1960s Picasso, Mondrian and Monet all received the Ben-Day treatment, which has a special piquancy when applied to Abstract Expressionism in *Brushstroke with Splatter* (1966). The extravagant gestures of action painting looked particularly ridiculous when translated into meticulous patterns of black outlines and coloured dots.

After these revolutionary works, Lichtenstein settled into a gradual evolution. Some works, such as *Cubist Still Life* (1974), continued with artistic parody, albeit with new textures such as wood graining. The *Perfect/Imperfect* series (1978–95) used the bold lines and bright colours of Pop to create a blank, inarticulate form of abstraction – 'dumb paintings', as Lichtenstein himself put it.

Despite the element of repetition in his career, Lichtenstein did experiment with different media, from film installations such as *Three Landscapes* (1970–71) to coloured sculptures, including the aluminium *Salute to Painting* (1986), installed at the Walker Art Center in Minneapolis. Six years later he produced the colossal *Barcelona Head* (1992), a concrete and ceramic sculpture inspired by Antoni Gaudí, which was installed on the city's waterfront in celebration of the Summer Olympics. Nothing could represent more clearly the extent to which Pop art took on the traditional artistic roles that it had once appeared to challenge.

MAGRITTE
MATISSE
MIRÓ
MODIGLIANI
MONDRIAN
MOORE

RENÉ
MAGRITTE

BELGIAN

1898–1967

This Belgian Surrealist's subversions of reality were made effective by the apparently naturalistic technique in which they were painted. Their most characteristic feature, a man in a bowler hat, is not only Magritte's alter ego but also an everyman drawn from the provincial bourgeoisie of his youth.

In 1916 René Magritte (born 1898, Lessines, Hainaut, Belgium) began two years of training at the Académie des Beaux-arts in Brussels. He progressed through the gamut of modernist styles, from Impressionism to Cubism and Futurism, and even had a dalliance with Constructivism. However, it was the influence of Giorgio de Chirico that led him back to a figurative style, which provided the ideal vehicle for his alienating, irrational imagery.

Although Magritte worked as a commercial artist throughout the interwar period, in 1926 he co-founded the Belgian Surrealist group, before moving a year later to Paris, where he joined up with the French Surrealists. At an early stage, he invented many of his characteristic motifs: familiar objects juxtaposed with machine-made spheres or giant skittles; inanimate things metamorphosing into living ones (or vice versa); and, most famously, words that cast doubt on the reality of the images, as in the famous inscription 'Ceci n'est pas une pipe' (This is not a pipe) below a painting of a pipe in the *Treachery of Images* (1929).

WHERE TO SEE MAGRITTE'S WORK

- Centre Georges Pompidou, Paris
- Los Angeles County Museum of Art
- Moderna Museet, Stockholm
- Musée Magritte, Brussels
- National Gallery of Art, Washington, DC
- Tate Modern, London

DID YOU KNOW?

Magritte's mother, Régina, a milliner before her marriage, threw herself into the river Sambre when René was 13. Her body, apparently with her face covered by her nightdress, was discovered 17 days later. Magritte hardly ever spoke about this event but referred to it obliquely in later paintings that depict a river, a flood or figures with veiled heads.

Perceptual games were more important to Magritte than Sigmund Freud's ideas about the unconscious, which were a strong motivation for other Surrealists. In *The Human Condition* (1933) an easel placed in front of a window exactly reproduces the landscape that it covers. This confusion of interior and exterior, so characteristic of Magritte's work, shows, in his own words, that, although 'we see it [the world] as being outside ourselves…it is only a mental representation of it that we experience inside ourselves.'

While the paintings from the 1930s, when Magritte was back in Brussels, followed on neatly from his work in the previous decade, the onset of World War II inspired a strong, but surprising, reaction. For a while he produced works that were strange parodies of Renoir, defying the horrors of the time but also estranging his Surrealist colleagues. This phase was followed immediately after the war by an even more peculiar period caricaturing Fauve art, which seems to have been a comment on the banality of contemporary artistic taste.

These were aberrations, and within a few years Magritte was producing some revivals of his earlier imagery that were, if anything, more powerful than the originals. A wander around the Musée Magritte in Brussels can provide moments of revelation, as the paintings, with their witty titles and strong physical presence, create an impact that is lacking in reproductions. Fine examples typify Magritte's penchant for reversing normal physical properties – while some works of this late period show boulders floating in the sky like balloons, *Empire of Light* (1953–4) represents a house, illuminated as if at night, in front of a blue sky. Nothing could focus the mind more effectively on the marvellous nature of reality as we actually experience it.

The Road to Damascus, oil on canvas, 1966

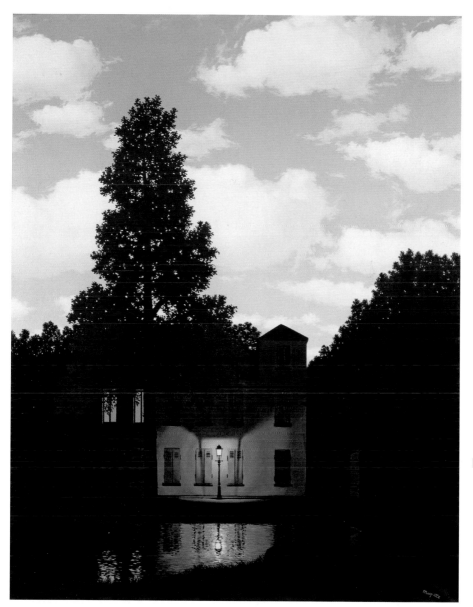

Empire of Light, oil on canvas, 1953–4

HENRI
MATISSE

FRENCH

1869–1954

One of the heroic figures of modernism, the French painter Henri Matisse (born 1869, Le Cateau, Picardy, France) produced compositions that were both disciplined and full of vitality. His palette was supremely sensual and expressive, and yet, even in his early Fauve period, he had a strong sense of design. During the course of his career, these qualities helped him to create some monumental images, examining different aspects of human experience, from the carnal to the metaphysical.

As a young man, Matisse initially embarked on a legal career before turning to art in his early twenties. He trained under the painters William-Adolphe Bouguereau and Gustave Moreau, at first painting interiors and still lifes in a subdued, conservative style. Around the turn of the 20th century, however, Matisse rapidly assimilated recent developments in Impressionism and Post-Impressionism, leading to a bolder and less naturalistic use of colour.

This culminated in such images as *Luxe, calme et volupté* (1904) that transformed the dots of Neo-Impressionism into an erotic spectacle. Another key work, *The Joy of Life* (1905), abandoned the earlier work's pointillist spots, combining intense hues with a composition based on sinuous curves.

Together with André Derain and Maurice Vlaminck, Matisse made such a sensation at the *Salon d'automne* of 1905 that the group was dubbed the Fauves, or 'wild

WHERE TO SEE
MATISSE'S WORK

- Barnes Foundation, Merion Station, Pennsylvania
- Centre Georges Pompidou, Paris
- Chapelle du rosaire, Vence
- Musée Matisse, Le Cateau
- Tate Modern, London
- Metropolitan Museum of Art, New York
- State Hermitage, St Petersburg
- Musée Matisse, Nice

DID YOU KNOW?

One of Matisse's many foreign trips was to Tahiti in 1930. Although he stayed by a lagoon and watched the making of the film *Taboo* by the director Friedrich Wilhelm Murnau, he wasn't very impressed by the island. Yet in the last years of his life, the visit inspired some striking paper cut-outs, such as *Memory of Oceania* (1953).

beasts'. The flatness of their pictures, their vibrant palette and exuberant brushwork were audacious, but in Matisse's case, at least, the compositions were also rigorously organized. This tendency became more prominent as Matisse moved away from his frenetic Fauvism to a more serene, almost musical style, exemplified by *The Red Room (Harmony in Red)* (1908). This work was purchased by the Russian collector Sergei Shchukin, who also commissioned the monumental *Dance* (1909–10) and *Music* (1910), in which the Apollonian and Bacchic tendencies are perfectly balanced.

Not all of Matisse's pictures were so decorative. Some, such as *Blue Nude – Memory of Biskra* (1907), present a more sculptural view of the human figure. The liberties with anatomy taken in this painting also characterize a contemporary work, *Reclining Nude I* (1907), one of the many bronzes in which Matisse pursued an interest in abstraction and simplification.

While some of his experiments, as in *Portrait of Mme Matisse/The Green Line* (1905), can be seen as a response to Pablo Picasso's Cubism, Matisse never emulated his rival. Instead, he explored formal problems akin to those of Cubism while offering an alternative vision through sensuous, colourful compositions, some based on his travels in Morocco. He also, from 1917, began to work in Nice, where he eventually settled. As well as painting subjects obviously set in the South of France, he used local models to pose in North African costume, as in *Odalisque with Red Culottes* (1921).

The Red Room (Harmony in Red), oil on canvas, 1908

These images, with their reminiscences of Eugène Delacroix's harem scenes, are emblematic of the nostalgia that gripped the French art world in the 1920s.

The last decades of Matisse's life were marked by some reprises, though never mere repetitions, of earlier themes, as in the immense mural *The Dance* (1932–3) for the Barnes Foundation in Merion Station, Pennsylvania. There was also a remarkable technical development, as Matisse took to using cut-out pieces of coloured paper in many of his final works. The results, including *The Snail* (1953), were expressive and luminous. Matisse also created the *Chapelle du rosaire* (1948–51) at Vence, where his stained-glass windows pour colour onto the white walls, for which he made vivid ceramic drawings of the Stations of the Cross. In this way, Matisse took his ultimate opportunity to indulge a lifelong preoccupation with clarity and light.

Plate VIII from the illustrated book *Jazz*, printed cut-out, 1947

JOAN
MIRÓ

SPANISH
1893–1983

Joan Miró (born 1893, Barcelona, Catalonia, Spain) played a vital role in the development of Surrealism in Paris but also drew heavily on the culture and landscape of his native Catalonia. At the time of the Spanish Civil War (1936–9) he expressed his allegiance to the Republican cause through his painting. However, unlike many contemporaries, he returned to Spain during General Franco's regime, and in his studios in Mallorca and Catalonia produced some of his most striking abstract works.

Miró began his training at the Escuela de Artes y Oficios de La Lonja in 1907. Although influenced by French artistic developments, including Fauvism and Cubism, his early painting was also inspired by the highly stylized Romanesque murals of Catalonia. Moving to Paris in 1920, he did not forget his roots, as shown in *The Farm* (1921–2), a vivid, luminous painting based on his family's property near Tarragona. This was followed soon afterwards by seminal works such as *The Hunter (Catalan Landscape)* (1924), filled with natural, often iconographic details, some more legible than others, which Miró freely dispersed across the canvas.

The liberties with reality that Miró took in these irrational, dream-like pictures attracted the attention of the Surrealists, although he never formally joined their movement. In some of his drawings, however, he began to experiment with the spontaneous

WHERE TO SEE
MIRÓ'S WORK

- Centre Georges Pompidou, Paris
- Fundació Joan Miró, Barcelona
- Fundació Pilar i Joan Miró a Mallorca, Palma
- Museum of Modern Art, New York
- National Gallery of Art, Washington, DC
- Solomon R Guggenheim Museum, New York

DID YOU KNOW?

Miró sold his painting of *The Farm* to the writer Ernest Hemingway, whom he had met at a boxing gym. Hemingway claimed that he won the right to buy the picture by rolling dice with his friend Evan Shipman. It cost 5,000 francs.

'automatic' techniques that they advocated. Meanwhile, in paintings such as *The Birth of the World* (1925), the ambiguous forms and stains of pigment suggest a process of free association, even though the compositions were actually worked out in preliminary studies. Other works are given a poetic quality by the presence of writing, in which the relationship of words to image is deliberately elastic.

In the 1930s Miró's work became particularly experimental, ranging from collage and abstract sculpture to wild, often violent paintings. He also used art as a political tool during the Spanish Civil War (1936–9). Like Picasso, in 1937 he contributed to the Spanish pavilion in the *Exposition internationale des arts et techniques dans la vie moderne* in Paris. However, while Picasso's *Guernica* (1937) has become an icon of

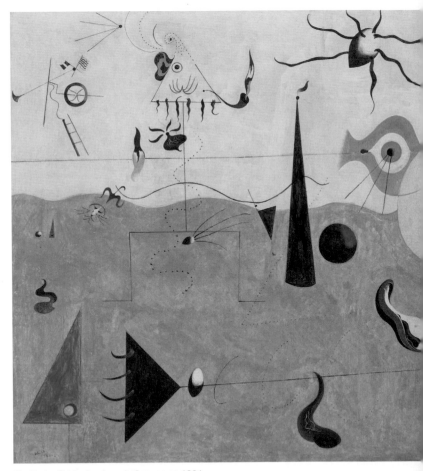

The Hunter (Catalan Landscape), oil on canvas, 1924

the period, Miró's *The Reaper* (1937) was lost at the end of the exhibition.

During World War II Miró retired to the relative safety of Mallorca, where he was left undisturbed by Franco's government. In series such as the *Constellations* of 1939–41 he continued to develop the surreal vocabulary that he had begun years before. The strange, lyrical imagery, expressed through clusters of black lines and coloured forms, has an intensity that also appears in his graphic art and ceramics of this period.

Miró's restless experimentation continued into old age. He sculpted enthusiastically, casting figures from a combination of mundane and natural objects, while his painting often took on a dark tone. However, monumental canvases such as *Blue II* (1961) offered a striking alternative, dominated by sensuous fields of colour.

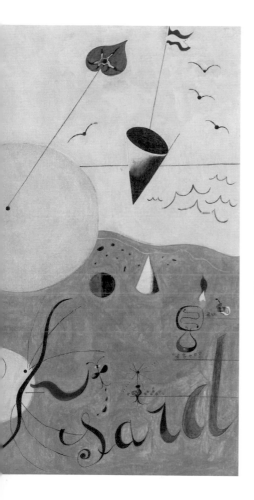

AMEDEO
MODIGLIANI

ITALIAN
1884–1920

A painter and sculptor of great refinement, Amedeo Modigliani (born 1884, Livorno, Italy) made elongated, linear figures and heads that are utterly distinctive. After succumbing to tubercular meningitis at the age of 35, he was celebrated as a paragon of the bohemian life – consumptive, gifted and addicted to drugs and alcohol.

Modigliani was born in the Italian port of Livorno to a Jewish merchant family that had fallen on hard times. He was trained in Florence and Venice, where his encounters with French art at successive biennales inspired him to move to Paris in 1906. He lived for a while in Montmartre, becoming friendly with other immigrant painters such as Gino Severini and Pablo Picasso, before settling in 1909 in Montparnasse. Up to this point, he had been influenced by the portraits of Paul Cézanne, whose works he had seen in a posthumous exhibition soon after his arrival in France. However, with the encouragement of Constantin Brâncuşi, he began to concentrate on sculpture, in a style that can be traced not only to Brâncuşi but also to Egyptian, tribal African and Oceanic carving.

Head (c.1911–12) exemplifies Modigliani's new approach. The outline evokes the shape of the block from which it was created, while the face is stylized and symmetrical. Although the slender nose and arched eyebrows are highly abstracted, the pouting lips give the whole composition an eerie vitality.

WHERE TO SEE MODIGLIANI'S WORK

- Courtauld Institute of Art, London
- Los Angeles County Museum of Art
- Metropolitan Museum of Art, New York
- National Gallery of Art, Washington, DC
- Solomon R Guggenheim Museum, New York

DID YOU KNOW?

In 1982 four sculptures (said to have been disposed of by the artist in 1909) were dredged from the Fosso Reale canal and hailed as lost masterpieces. They turned out to be fakes made with ordinary tools, and the hoax inspired an advertising campaign with the logo 'It's easy to be talented with Black & Decker'.

After the outbreak of World War I, ill health and a shortage of materials prevented Modigliani from carrying on his sculpture. The rest of his life was devoted to painting. Apart from a brief divisionist period in 1914, Modigliani's later pictures, which often depict the female nude, are dominated by sinuous lines and flat, graceful bodies. This style reflects his admiration of the panels by Simone Martini and Duccio that he had seen in Tuscany in 1901, although the subject matter could hardly be more different. Renaissance mythologies and contemporary pornography are other plausible sources of inspiration.

While the reclining, and sometimes seated, nude provided Modigliani's most popular theme, he also produced memorable portraits, including some of his lover, Jeanne Hébuterne. These pictures, with delicate hues and elegant gestures give an impression of lightness and ease. However, Modigliani died from health problems aggravated by susbstance abuse and Jeanne committed suicide a day after his death.

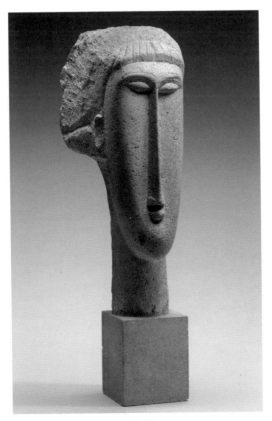

Head of a Woman, limestone, 1910–11

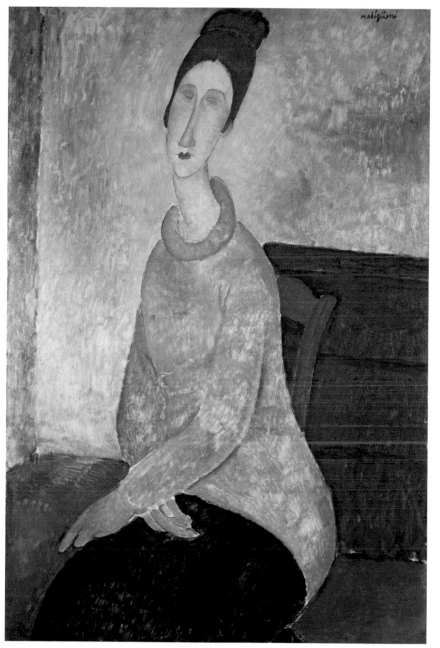

Jeanne Hébuterne in Yellow Sweater, oil on canvas, 1918–19

PIET
MONDRIAN

DUTCH

1872–1944

In the hands of Piet Mondrian (born 1872, Amersfoort, The Netherlands) abstraction became not just an artistic style but a philosophy and a way of life. His striking geometric idiom, Neo-Plasticism, was associated from 1917 with De Stijl, a movement so rigorous that it split in the mid-1920s over a disagreement about whether painters should use diagonal lines. Separated from De Stijl, Mondrian continued to develop his brand of Neo-Plasticism up until his death in wartime exile in the United States.

Mondrian, who spelt his name 'Mondriaan' until 1906, studied painting at the Rijksakademie van Beeldende Kunsten, Amsterdam, from 1892 to 1894 and again from 1895 to 1897. His early paintings reflect the landscape of his native Netherlands, as seen through a variety of styles, including Symbolism, Impressionism and Neo-Impressionism, before he developed his own version of Cubism in works such as *Grey Tree* (1911) and *Flowering Appletree* (1912).

Influenced particularly by the mystical movement known as Theosophy, which espoused a belief in an essential spiritual reality beyond the physical world, Mondrian gradually abandoned figurative painting in favour of increasingly abstract works. Shortly before his move to Paris in 1912, Mondrian's Cubist pictures became highly abstract, with patterns of lines that did not make a conventional distinction between the edges and centre of the canvas. Soon afterwards, Mondrian began to

WHERE TO SEE MONDRIAN'S WORK

- Gemeentemuseum, The Hague
- Kröller-Müller Museum, Otterlo
- Museum of Modern Art, New York
- Stedelijk Museum, Amsterdam
- Villa Mondriaan, Winterswijk

DID YOU KNOW?

Mondrian's influence extended far beyond painting to the worlds of fashion and design. In 1965 Yves Saint Laurent showed his 'Mondrian dress' which has become a fashion classic (and has been copied countless times), while Gerrit Rietveld's 'Red and Blue Chair' (1918) takes direct inspiration from Mondrian's *Compositions*.

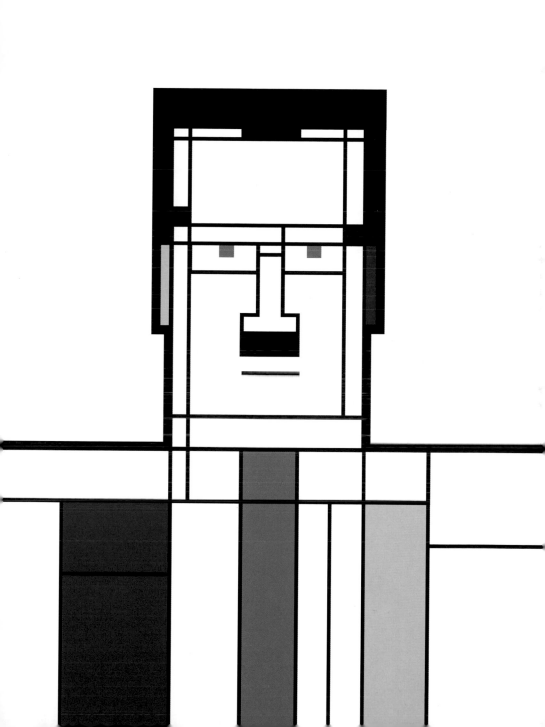

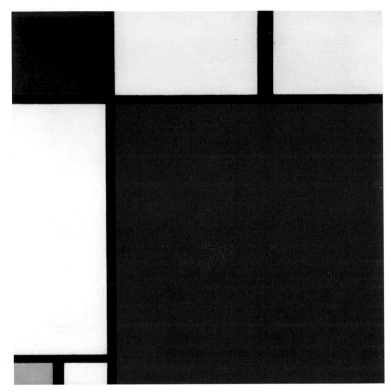

Composition with Red, Blue and Yellow, oil on canvas, 1930

call his disciplined, objective pictures *Compositions*, emphasizing their non-figurative, formal qualities.

While spending World War I in the Netherlands, Mondrian began to adopt a very strict approach to abstract painting, creating grids without any colour as well as works showing patterns of coloured squares without lines. He also published important theoretical writings in Theo van Doesburg's periodical *De Stijl*, before returning to Paris in 1919, where he remained until 1938.

Back in France, Mondrian developed his trademark Neo-Plasticism, characterized by black lines enclosing areas of grey, white and primary colours. His dynamic, asymmetric compositions explored the relationship between different sections of the canvas with a remarkable tautness and discipline. His aim was to reduce painting to its simplest elements, only using a strictly defined range of lines and shapes, and to achieve a perfect balance on the canvas. Van Doesburg's insistence on using diagonals even forced Mondrian to quit De Stijl in 1925, after which he wreaked

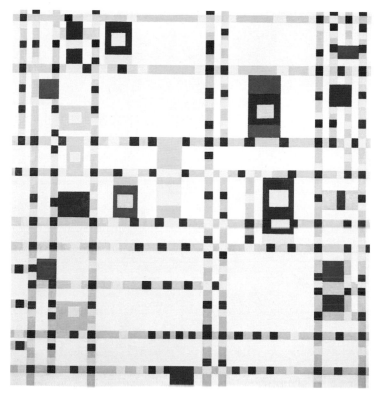

Broadway Boogie Woogie, oil on canvas, 1942–3

his own revenge by creating diamond-shaped paintings that emphasized the horizontal and vertical lines enclosed by the frames. He also became associated with other abstract groups, especially Cercle et Carré and, from 1931, its successor, Abstraction-Création.

Mondrian's own studio, of which photographs survive, demonstrated how he attempted to transfer the principles of abstract art to interior design. Although most of his own projects were unrealized, he had an important influence on modernist architects in the 1930s. This was also a period in which he experimented systematically with his painting, producing increasingly complicated and dynamic compositions.

With the approach of World War II, Mondrian left Paris, spending two years in England, where he became friendly with the abstract artist Ben Nicholson. Finally, in 1940, he moved to New York. His experience of the modern metropolis had an energizing influence on his late paintings, above all *Broadway Boogie Woogie* (1942–3), which shows a dynamic reaction to the pulsating rhythms of the city.

HENRY MOORE

BRITISH
1898–1986

Widely acknowledged to be the most important British sculptor of the 20th century, Henry Moore (born 1898, Castleford, Yorkshire, UK) concentrated on representing the human body but drew inspiration from all aspects of the natural world, while at times tending towards complete abstraction. His imagery extended from Christian themes to scenes of London life in the Blitz, but he is most celebrated for his stone figures of reclining women, which include voids that are as integral to the composition as the forms that surround them.

Moore was born into a Yorkshire mining family and, encouraged by his father, trained as a teacher. His artistic education began at Leeds School of Art in 1919, followed two years later by a scholarship to the Royal College of Art in London. Despite the undeniable variety of his output, Moore remained loyal to his early vision, inspired in part by photographs of pre-Columbian art. Moore was part of a movement that encouraged 'direct' carving, rather than using assistants to transfer onto a larger scale designs developed in small models. This technique led the young Moore to produce bulky, block-like shapes that recall the reclining sculptures (known as Chacmool) of pre-Columbian Mesoamerica, which he admired intensely.

Moore was also heavily influenced by the work of modern European artists such as Pablo Picasso, Jean (Hans) Arp and Alberto Giacometti. During the 1930s he

WHERE TO SEE MOORE'S WORK

- Henry Moore Foundation, Perry Green, Much Hadham
- Henry Moore Sculpture Centre, Art Gallery of Ontario, Toronto
- The Hepworth Wakefield
- Leeds Art Gallery
- Tate Britain, London
- Yorkshire Sculpture Park, Wakefield

DID YOU KNOW?

As a child, Moore often massaged the back of his mother, who suffered from severe rheumatism. His experience of the differences between the soft parts of the back and the hard bone led to equivalent formal contrasts in his work. It also encouraged him to concentrate on the maternal aspects of the female body.

was associated with Unit One, a British group dedicated to non-figurative art, while his interest in Surrealism led him towards a suggestive organic abstraction, as in *Two Forms* (1934). However, his subsequent work was profoundly affected by wartime experiences in London, where he produced evocative drawings of sleeping figures sheltering from the Blitz in Underground stations.

During World War II Moore created the memorable *Madonna and Child* (1943–4) for St Matthew's church in Northampton, which was followed by some secular maternal sculptures. Despite these relatively conventional works, during the 1950s Moore's figures became more idiosyncratic, often based on the configurations of pebbles or bones. Reclining bodies were reduced to expressive shapes that enclosed extravagant voids, often in an outdoor setting. By the 1960s Moore was working on a monumental scale, as in a bronze commission for the Lincoln Center in New York, *Reclining Figure* (1963–5), in which the human form takes on the grandeur of a rocky landscape.

Moore's prestige in his last years was enhanced by spectacular international exhibitions as well as by his own donations to public collections. In 1977 the Henry Moore Foundation was set up at Dane Tree House, the Hertfordshire home to which he had moved from London during World War II. Its aim is to promote not only Moore's work but the art of sculpture in general.

Reclining Mother and Child, bronze, 1975–6

NICHOLSON
NOLAN

BEN
NICHOLSON

BRITISH
1894–1982

Ben Nicholson (born 1894, Denham, UK) was a key figure in British modernism, whose work ranged from abstract, geometric reliefs to delicate Cubist compositions.

The son of the artists William Nicholson and Mabel Pryde, Nicholson began a brief training at London's Slade School at the age of 16, although he later admitted that he spent most of his time playing billiards. Having been excused from military service due to ill health, in 1920 he married the painter Winifred Roberts, with whom he travelled regularly in Europe. Visits to Paris exposed him to the work of Pablo Picasso and other modernists, and he created his first abstract paintings in 1924, when he also became a member of the avant-garde Seven and Five Society.

In the late 1920s Nicholson spent much of his time in St Ives, where some of his pictures recalled the naive style of Alfred Wallis, the fisherman painter whose work was promoted by Nicholson and his friend Christopher Wood. As his marriage with Winifred deteriorated in the early 1930s, Nicholson became close to the sculptor Barbara Hepworth, who was also moving towards an uncompromising form of abstraction. He visited Mondrian in Paris and participated in a variety of groups that promoted non-figurative art, including Abstraction-Création and Unit One.

The 1930s was a particularly productive phase in Nicholson's career. *1932 (Au Chat Botté)* (1932) is a masterful Cubist still life incorporating writing and reflections

WHERE TO SEE NICHOLSON'S WORK

- Kettle's Yard, University of Cambridge
- Manchester Art Gallery
- Scottish National Gallery of Art, Edinburgh
- Tate Britain, London
- Tate St Ives, Cornwall

DID YOU KNOW?

Nicholson's abstract reliefs were often made in accordance with the Golden Section, the ratio extensively used in classical sculpture and architecture, and by other modernists such as Le Corbusier. With their ideal proportions and pristine whiteness, many of Nicholson's works embody his quest for a reality beyond everyday appearance.

in a shop window, while other works abandon references to external reality altogether. *1935 (white relief)* (1935) is a monochrome sculpture made up of superimposed planes, which cast delicate shadows, animating the composition's rigorous geometry. White circles and rectangles have rarely been so vivacious.

Although many of his works in this period have a restrained palette, Nicholson did not eschew brighter hues, which at times evoke aspects of the natural world. After Nicholson and Hepworth, who had married in 1934, settled in Cornwall during World War II, St Ives particularly inspired them and became a centre for modern and abstract British art. Led by Nicholson and Hepworth, the St Ives School of artists flourished, including Naum Gabo, Patrick Heron, Bernard Leach and Peter Lanyon.

During this period more figurative references began to reappear in Nicholson's work, as in *1943–45 (St Ives, Cornwall)* (1943–5) which, with its view of the harbour, engaged

August 1956 (Val d'Orcia), oil, gesso and graphite on board, 1956

with visions of the English landscape that were particularly popular (and saleable) at the time. This move to figuration was further encouraged by frequent trips to the Mediterranean after the end of the War. These encouraged Nicholson to use warmer colours derived from landscapes, although works such as the monumental painting *August 1956 (Val d'Orcia)* (1956) remained highly enigmatic, drawing on the imagery of the Cubist still life, to which Nicholson returned throughout his career.

In 1957, after his divorce from Hepworth, Nicholson married the photographer Felicitas Vogler, with whom he moved to Switzerland. He began to concentrate on graphic art and large-scale reliefs, including a wall for *documenta 3* at Kassel in 1964. His final period in England, to which he returned in 1971, was characterized mostly by graphic art. Although ill health had restricted his choice of media, his late drawings still displayed the vitality and delicacy of line that characterized so much of his career.

SIDNEY
NOLAN

AUSTRALIAN
1917–92

Sir Sidney Nolan (born 1917, Melbourne, Australia) created memorable paintings that strongly evoked the wildness of his native Australia, sometimes even to the point of exaggeration. There is more to this country than desperate endeavours in harsh surroundings, but these themes, represented in a stark, simplified style, won Nolan great international renown and enabled him to become arguably the best-known Australian artist of all time.

The son of a tram driver, Nolan partly educated himself in the public library, though he also variously attended Prahran Technical College and the National Gallery of Victoria Art School in Melbourne, as well as working as a commercial artist and sign-writer. Modernist influences can be seen in his highly abstracted paintings of the 1930s, and from 1938 onwards he was nurtured and encouraged by art patrons Sunday and John Reed, whose house became a central meeting place for artists and thinkers of Australia's avant-garde. Nolan became a leading figure in this movement, founding the Contemporary Art Society. Like Pablo Picasso before him, he also designed sets and costumes for the Ballets Russes, albeit in Sydney rather than Paris.

Military conscription in 1942 consigned him for two years to the interior of Victoria. He recreated this flat, luminous landscape in a simplified style executed in quick-drying commercial enamel. Soon afterwards, while living with the Reeds, he began

WHERE TO SEE NOLAN'S WORK

- Art Gallery of New South Wales, Sydney
- British Museum, London
- Metropolitan Museum of Art, New York
- National Gallery of Australia, Canberra
- Tate Modern, London
- Victoria and Albert Museum, London

DID YOU KNOW?

Nolan's celebrated image of Ned Kelly riding across the bush was regarded as so iconic that it was used in the opening ceremony of the 2000 Sydney Olympics.

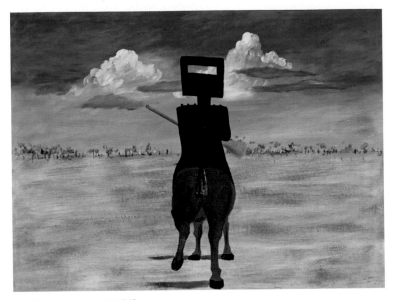

Ned Kelly, enamel on board, 1946

his most famous series of works, based on the life of a 19th-century Australian outlaw. It comprises 27 paintings and epitomizes the interrelation of European modernism and Australian folklore and landscape that formed Nolan's work. *Ned Kelly* (1946) silhouettes the doomed gunslinger in his homemade armour, with the helmet simplified into a black rectangle against the sky. It is the most famous, but not the last, picture that Nolan made of Australian folk heroes and adventurers.

Nolan sealed his reputation with *Pretty Polly Mine* (1948), a witty painting of a mineowner and his parrot set amid the incongruous desolation of the bush. It was acquired in 1949 by the Art Gallery of New South Wales, while a couple of years later the Tate purchased *Inland Australia* (1950), an aerial view of red rocks and craters. By this time the art historian Kenneth Clark had dubbed Nolan Australia's 'only real painter' and urged him to move to England, which he did in 1953.

During this period Nolan travelled extensively in Europe and America. Although classical mythology, African animals and the Antarctic made appearances in his paintings and prints, he remained principally an artist of Australiana. Ned Kelly resurfaced in Nolan's work in the 1950s, while the explorers Burke and Wills were the subjects of works made in Nolan's new medium of polyvinyl acetate and oil. These austere, scraped pictures offer a singular view of Australia's founding myths. *Burke* (1962) presents the naked rider on his camel as if he is about to merge into the desert, with only the top of his head rising above the horizon.

O'KEEFFE

GEORGIA
O'KEEFFE

AMERICAN
1887–1986

Georgia O'Keeffe (born 1887, near Sun Prairie, Wisconsin, USA) was an American painter whose work defies any attempts to classify her. Although at times her art bordered on the abstract, it was always based on intense experience of the physical world, above all the nature and landscape of various regions of the United States.

O'Keeffe was trained in Chicago and New York. Her early drawings, like most of her work, respected the flatness of the picture surface and were influenced by a variety of sources, including European art nouveau. An interest in synaesthesia is reflected in canvases such as *Blue and Green Music* (1919–21), and she also made numerous pastels and drawings based on plant and wave forms.

While teaching in Canyon, Texas, in 1917, O'Keeffe made a visit to New York, where she met her future husband, the avant-garde photographer and dealer Alfred Stieglitz. Stieglitz's photographs of O'Keeffe are remarkable for their rigour and formal invention, while his summer home in Lake George, New York state, provided a rural studio and source of inspiration for O'Keeffe during the 1920s.

O'Keeffe's work in Lake George ranged from rhythmic abstractions to naturalistic pictures of barns and her studio, while from 1924 she also included leaves and flowers, viewed from close up, in hot, sensuous colours. *Two Calla Lilies on Pink* (1928), for example, seems to invite an erotic interpretation, though the artist denied this.

WHERE TO SEE O'KEEFFE'S WORK

- Art Institute of Chicago
- Alfred Stieglitz Collection, Philadelphia Museum of Art
- Georgia O'Keeffe Museum, Santa Fe, Texas
- National Museum of American Art, Smithsonian Institution, Washington, DC

DID YOU KNOW?

O'Keeffe was a member of the National Woman's Party, which she joined in 1914, for over seven decades. She lobbied tirelessly for an equal rights amendment, declaring to Eleanor Roosevelt that she 'would like each child to feel...that no door for any activity that they may choose is closed on account of sex'.

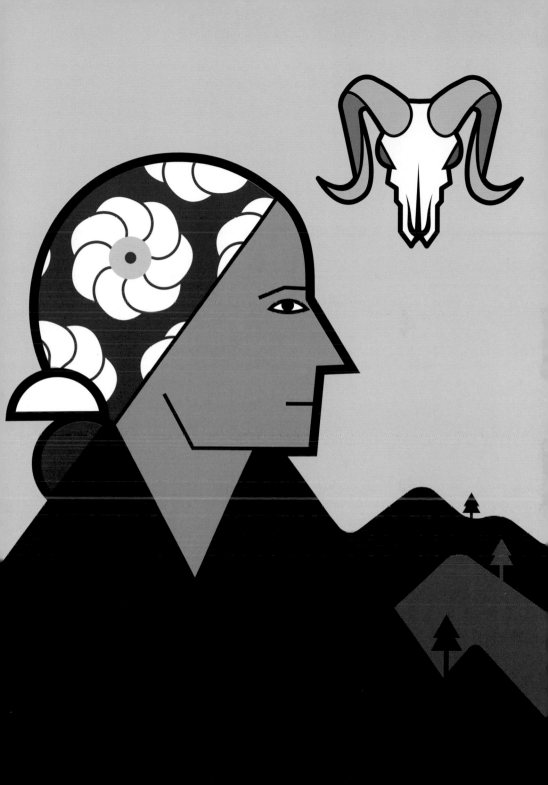

During this fertile period, O'Keeffe's output ranged between abstracted, often night-time views of Manhattan and paintings of the desert. By the end of the 1920s O'Keeffe had begun to develop a particular interest in New Mexico, where she was to settle in 1949. She was particularly struck by the bleached animal bones scattered across the wilderness, which she brought back in barrels to New York. They became the subject of novel, sometimes vaguely surreal, still lifes, adorned with flowers or represented floating above the desert. Although O'Keeffe was initially fascinated by the skull, her interest gradually shifted in the 1940s to the pelvic bone and socket, which she often painted with the sky shining through the empty hole as in *Red with Yellow* (1945).

Despite her fear of flying, O'Keeffe made magnificent aerial views, which ranged from semi-abstract charcoal drawings to evocative pictures of rivers or cloudscapes, as in the immense *Sky above Clouds IV* (1965). Although in her later years she was almost blind, O'Keeffe continued to work with her assistant Juan Hamilton, who in 1982 cast a monumental abstract sculpture from a much earlier model for exhibition at the San Francisco Museum of Modern Art.

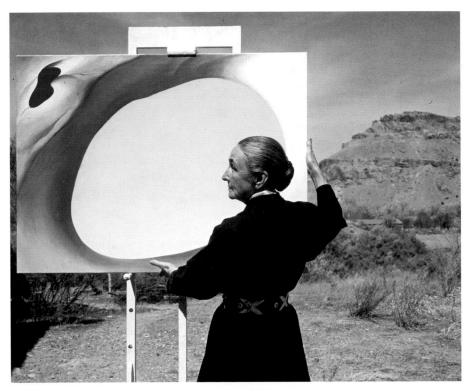

O'Keeffe with *Red with Yellow* from the *Pelvis* Series, oil on canvas, 1945

PICASSO
POLLOCK

PABLO
PICASSO

SPANISH
1881–1973

Pablo Ruiz Picasso (born 1881, Malaga, Spain), the most celebrated artist of the 20th century, produced a body of work that ranged from the disconcerting to the ingratiating, from the esoteric to the sentimental. He combined inventiveness and technical skill with emotional depth, practising modern and classical styles, and merging them into strange hybrids. *Guernica* (1937) is one of the most powerful images of war in Western art, and even in disregarded later paintings he draws out the viewer's imagination through the choice of a particular hue, the enlargement or relocation of an eye or nose, or some other liberty with the human form.

At an early age, Picasso showed a spectacular talent for drawing, and his fine sense of line in the paintings of his so-called 'Blue Period' (1901–4) is more impressive than their monotonous palette. In 1904 he progressed to the 'Rose Period' – during which he created paintings that owe their warmth not just to their brighter hues, but also to their subjects, the circus and the *commedia dell'arte* (an Italian masked theatre).

It was with the discovery of African and Oceanic sculpture, together with statues from pre-classical Iberia, that Picasso's career truly developed. With *Les Demoiselles d'Avignon* (1907) he created a painting of vivid, almost sculptural figures, on which he inflicted distortions that complement the vaguely misogynistic theme and anticipate the pictorial language of Cubism. For five years or so, Georges Braque and Picasso

WHERE TO SEE
PICASSO'S WORK

- Art Institute of Chicago
- Centre Georges Pompidou, Paris
- Musée Picasso, Paris
- Museo Nacional Centro de Arte Reina Sofía, Madrid
- Museum of Modern Art, New York
- Museo Picasso, Malaga
- Museu Picasso de Barcelona
- Tate Modern, London

DID YOU KNOW?

In October 1944 Picasso joined the French Communist Party, which he described as 'the logical outcome of my whole life and of the whole body of my work'. He even attended a Congress of Intellectuals for Peace, held in Poland four years later, though photographs of the event show him looking rather bored.

worked closely together, creating Cubist compositions out of intersecting planes, some so sharp-edged that you feel as though you could touch them. Canvases resembled reliefs and often there was no clear distinction between the objects and the space around them.

The 'Analytical Cubist' (1908–12) paintings became extremely abstracted and monochrome and eventually Picasso and Braque injected vitality by constructing with coloured planes, with the outlines of objects and even pointillist dots added on top. The impetus for this development, known as 'Synthetic Cubism', was Braque's invention in 1912 of *papier collé*, the creation of works with pasted paper, which Picasso had anticipated by sticking a piece of oil-cloth onto a canvas in the same year.

Isolated during World War I, with many of his French colleagues conscripted, Picasso continued his Cubist works, and also indulged his academic technique in some eye-catching portraiture. Even more significant was the eerie, distorted classicism that he devised for later works like *Three Women at the Spring* (1921).

During the interwar period, Picasso used both Cubism and classicism for a variety of disturbing effects that brought him the Surrealists' admiration. He only partly

Guernica, oil on canvas, 1937

reciprocated, but their enthusiasm was justified by the dislocations found in such works as *Studio with Plaster Head* (1925), while an ambiguous personal mythology is created in the etchings known as the *Vollard Suite* (1930–37).

It was Cubism, or a version of it, that triumphed in 1937, when Picasso provided an altarpiece-sized canvas for the Spanish pavilion at the *Exposition internationale des arts et techniques dans la vie moderne* in Paris. *Guernica* is an image of the devastation caused to a Basque town during an air-raid by the Luftwaffe in the Spanish Civil War (1936–9). While not a single bomb is represented in the painting, characters such as a bull and a horse are potent emblems of the aggressors and their victims.

Picasso produced a few more large-scale works that are variations on Old Masters' paintings that he particularly admired. These notably include the 58 paintings in the *Las Meninas* series (1957), after Diego Velázquez. In his old age, Picasso held court at his base in the south of France, in which he could attend the local bullfights almost as if he had returned to Spain. He became a popular hero, if no longer a critical one, and continued to create ceramics, sculptures and a wealth of paintings of varying merit until close to his death.

JACKSON
POLLOCK

AMERICAN
1912–56

Jackson Pollock's 'action painting' was an exhilarating form of Abstract Expressionism in which the canvas was laid on the floor and furiously worked over with brushes, turkey-basters, trowels, sticks and, of course, the artist's hands. Instead of being centred compositions, Pollock's 'all-over' pictures were records of the dynamic physical process by which they were made. This did not mean that Pollock gave no thought to the colours he used or the order in which they were applied: his method was frenetic but not totally spontaneous.

During his childhood Jackson Pollock (born 1912, Cody, Wyoming, USA) constantly moved with his family to and from California. In 1930 he settled in New York, where he studied at the Art Students League under the muralist Thomas Hart Benton. He subsequently joined the Federal Art Project, a government initiative intended to provide employment during the Depression.

Following psychiatric treatment for alcoholism in 1938, Pollock made the first radical change to his artistic practice. After his drawings were used as part of his therapeutic analysis, he became interested in Jungian theory and began to raid his unconscious for symbols, which were then translated into his paintings. This approach gave pictures such as *Bird* (*c.*1938–41) and *Male and Female* (*c.*1942) a Surrealist quality, combined with a variety of Cubist and other modernist features.

WHERE TO SEE POLLOCK'S WORK

- Kunstsammlung Nordrhein-Westfalen, Düsseldorf
- Museum of Fine Arts, Dallas
- Museum of Modern Art, New York
- National Gallery of Art, Washington, DC
- Philadelphia Museum of Art
- Solomon R Guggenheim Museum, New York

DID YOU KNOW?

Pollock was a great admirer of American Indian sand paintings, which encouraged him to stretch his work out on the floor. The ritualistic aspect of this procedure was appreciated by the critic Harold Rosenberg, who wrote in 1952 of one of Pollock's creations, 'on the canvas was not a picture, but an event'.

The next important development took place after Pollock's marriage to the abstract artist Lee Krasner and the couple's relocation to East Hampton in 1945. In the countryside, Pollock made his studio from an old barn next to a creek, drawing inspiration from the area's watery light, reed beds and natural rhythms. Between 1947 and 1952 Pollock created a series of mural-sized abstract works, which he identified with numbers, as in *Number 1, 1950 (Lavender Mist)* (1950) (the helpful subtitle was suggested by his champion, the critic Clement Greenberg). Here the figurative elements of his earlier work have been replaced with whip-like lines and splatters, made by dripping, pouring and throwing house paint from various directions onto the canvas.

Although they were at first poorly received, Pollock's innovations transformed the world of American painting, and he became the figurehead of the Abstract Expressionist movement, which moved the focus of the contemporary art world from Europe to the United States. In 1949 *Life* magazine ran a celebrated photograph of Pollock in action, asking 'Is he the greatest living painter in the United States?'

Towards the end of this period Pollock's mental and physical state deteriorated. His work darkened literally, as he used more black paint, and metaphorically, with the return of Jungian symbols and archetypes. This approach is exemplified by *Portrait and a Dream* (1953), in which the Moon-woman is apparently an image of his wife, contrasted with his own self-portrait. In 1956 he was killed in a drink-driving accident in East Hampton, New York.

Number 1, 1950 (Lavender Mist), oil, enamel and aluminium on canvas, 1950

QUINN

MARC QUINN

BRITISH

BORN 1964

Marc Quinn (born 1964, London, UK) came to prominence in the 1990s as one of the provocative Young British Artists ('YBAs'), an informal group of artists (many of them graduates of Goldsmiths College of Art) that included Damien Hirst, Tracey Emin, Sarah Lucas and Mark Wallinger. His work attracted attention for its use of unconventional procedures and materials, most notably in the bust *Self* (1991), a work made from eight pints of the artist's frozen blood, of which Quinn creates a new version every five years to mark the physical deterioration that is implicit in the aging process.

Quinn learned to cast in bronze as an assistant to the sculptor Barry Flanagan, before graduating from Cambridge University in 1986. Despite being familiar with such traditional materials, he gained most renown for his use of more innovative techniques. *Self* was not the only work in which Quinn froze organic material. *Garden* (2000), which was installed at the Fondazione Prada in Milan, manipulates nature by showing an array of plants that would not normally grow together. They have been conserved by being encased in silicone and frozen at very low temperatures. In this way, their immortality is assured in a similar manner to Quinn himself through *Self* – that is, as long as the electricity is switched on. Another form of biological preservation features in *Portrait of Sir John Edward*

WHERE TO SEE
QUINN'S WORK
- National Portrait Gallery, London
- Tate Modern, London
- Museum of Modern Art, New York
- Centre Georges Pompidou, Paris

DID YOU KNOW?

Quinn's best-known work is referenced in the popular British comedy *Absolutely Fabulous*, when the central character Edina Monsoon decides to become a collector of contemporary art: 'I want one of those blood-heads, you know, those frozen blood-heads filled with blood. Anything that's in the Saatchi collection, I want things like that.'

Sulston (2001), where Quinn has exhibited a sample of the DNA of Nobel Prize-winning scientist Sulston (who was instrumental in sequencing the human genome) in bacteria set in agar jelly.

Quinn's homages to celebrity also include a remarkable sculpture of the model Kate Moss, though its final appearance is less esoteric than Sulston's. The piece, known as *Siren* (2008), is fashioned from solid gold and was exhibited next to classical statuary at the British Museum in London. It inevitably invites comparison with the platinum and diamond skull made by Quinn's YBA contemporary Damien Hirst.

Despite his association with the YBAs and his creation of sculptures from blood and faeces, Quinn is not merely a sensationalist. In exploring the transience of our existence, as well as human attempts to control natural processes, Quinn has attempted to break down divisions between science and art, and has consistently maintained a high visual impact with a strong emphasis on the human form and its biology. He has also challenged ideals of beauty, above all in his elevation of *Alison Lapper Pregnant* (2005) to the fourth plinth in Trafalgar Square, where he created a celebration of the artist Alison Lapper and her body.

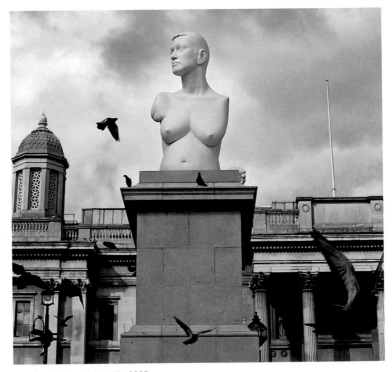

Alison Lapper Pregnant, marble, 2005

RODCHENKO
ROTHKO

ALEKSANDR
RODCHENKO

RUSSIAN

1891–1956

Aleksandr Rodchenko (born 1891, St Petersburg, Russia) made a vital contribution to the development of Russian Constructivism. He famously abandoned easel painting for media such as poster design and photography that were deemed less individualistic, more useful to society, and in keeping with the role of the artist as a driver of social change.

Rodchenko was brought up in Kazan, Russia, where he made the first of his many stage designs and met his lifelong partner and collaborator Varvara Stepanova. As a student in Moscow from 1914, he was influenced by both Vladimir Tatlin and Kasimir Malevich, the founder of the abstract geometric style known as Suprematism. However, he also rejected the mystical elements upon which Malevich and other artists were focusing, arguing that 'a constructively organized life is above the mystical art of magicians'.

Rodchenko's own paintings and drawings consisted of geometric, sometimes monochrome planes with esoteric names, as in *Nonobjective Painting Composition 66/86: Density and Weight* (1919). In making such works, he used a compass and ruler in order to banish any element of personal expression. Rodchenko referred to this precise approach as 'linearism', and this emphasis combined with his social concerns to form Constructivism.

WHERE TO SEE RODCHENKO'S WORK

- State Russian Museum, St Petersburg
- Museum of Modern Art, New York
- Pushkin State Museum of Fine Arts, Museum of Private Collections, Moscow
- State Museum of Contemporary Art, George Costakis Collection, Thessaloniki

DID YOU KNOW?

Rodchenko's father had many professions. He had even performed 'powdered and dressed in thin tights' as a living statue during palace balls. As Aleksandr said: 'It was a well-paid but extremely repugnant job, the ladies mocked them and teased them by fanning certain parts of their bodies, so that they [the men] had to cover themselves with their shields.'

After the Russian Revolution Rodchenko took up influential roles as a teacher and cultural administrator, emphasizing the importance of construction as opposed to esoteric artistic experiment. In 1917 he designed geometric, reflective light fixtures for the Kafe Pittoresk in Moscow, and in 1921 he formed the Working Group of Constructivists (within Inkhuk, the Institute of Artistic Culture in Moscow), collaborating with Stepanova and other figures such as Konstantin Medunetsky and Georgy and Vladimir Stenberg.

In that year, after exhibiting with fellow Russian avant-garde artists at the *5 x 5 = 25* exhibition, Rodchenko rejected easel painting, claiming that it was as 'unnecessary as church building. No good for anything on earth'. At this time he produced a number of oval plywood constructions, which were in turn superseded by more utilitarian projects, such as furniture, clothing (including workers' attire known as *prozodezhda*) and fabric designs. Rodchenko's focus on these everyday objects stemmed from a desire to transform perceptions of them and to pave the way for a more innovative approach to their design.

Rodchenko often collaborated on propaganda projects with the poet Vladimir Mayakovsky, for whose books he made covers and photomontage illustrations. One title, *About This* (1923), shows Rodchenko's fresh approach to photomontage, his clever juxtaposition of original photography with flashy American advertising imagery offsetting Mayakovsky's narrative. Together, the two men also produced posters, signs, wrapping paper and advertisements for newspapers and magazines. Although most of these were commissioned by State organizations, as a part of their vision for social change, the pair developed their own forms of propaganda, espousing technical developments and improved working conditions for the proletariat.

Rodchenko's designs of this period were bold, geometric and asymmetrical. This approach also informed his photography, which became an increasingly important part of his work from the mid-1920s. The memorable portrait of his mother reading (1924) has an undeniable tenderness, but generally Rodchenko's photographs, in which athletes, machinery and modern architecture loom large, have arresting, unconventional angles. In *Steps* (1930) the female protagonist becomes part of a semi-abstract composition, the regularity of her surroundings dominating the frame. While some of these photographs show human elements, as in the playful angles of *Taxi Driver* (1933), their alienating effects led to criticisms that Rodchenko was pandering to Western formalism. As the Soviet authorities promoted more conservative forms of realism during the 1930s, Rodchenko came under increasing pressure from the State and eventually gave up photography altogether in 1941.

In his final period Rodchenko returned to painting, depicting circus scenes, as well as developing an individual form of expressive abstraction, for example in *Expressive Rhythm* (1943–4). Although these later works are visually interesting, it is hard not to see them as a retreat from the grand social aims of the Constructivism which he pioneered.

Rubber Dummy Advertising Poster, lithograph, 1923

MARK
ROTHKO

AMERICAN
1903–70

Mark Rothko (born 1903, Dvinsk, Russian Empire, now Daugavpils, Latvia) played a vital role in the spectacular variant of Abstract Expressionism known as Color Field Painting. His monumental canvases are dominated by expanses of pigment with irregular borders that seem to float above their backgrounds. As well as being visually exciting, his work has a sublime, even tragic quality, and was commissioned for both religious and secular settings.

As a boy, Rothko immigrated with his family to Portland, Oregon. In 1921 he went to Yale University on a scholarship but left without taking his degree. In New York he spent a short period studying at the Art Students League and began painting in oil, mostly in a grim Expressionist style, as well as making watercolours and illustrations. In 1935 Rothko co-founded the group known as The Ten, with which he exhibited until 1940, but in general this period was one of considerable hardship for him.

During the 1940s, like other artists associated with Abstract Expressionism, Rothko was influenced by both European Surrealism and the ideas of Carl Gustav Jung. He expressed Jung's belief in the collective unconscious by creating mythical figures that were a hybrid of human, animal and vegetal forms. Eventually, these metamorphosed into highly abstracted, biomorphic shapes in such paintings as the luminous *Horizontal Vision* (1946).

WHERE TO SEE ROTHKO'S WORK

- Menil Collection, Houston, Texas
- Metropolitan Museum of Art, New York
- National Gallery of Art, Washington, DC
- Museum of Modern Art, New York
- Rothko Chapel, Houston, Texas
- Tate Modern, London

DID YOU KNOW?

Even though Rothko left Yale University without completing his studies, the university eventually honoured him decades later. In 1969 he was awarded an honorary Doctor of Fine Arts degree in acknowledgement of his contribution to the evolution of modern art.

No. 3/No. 13, oil on canvas, 1949

It was in the late 1940s that he made the leap into true abstraction by creating immense rectangles of colour, such as *No. 3/No. 13* (1949) which seem to pulsate, thanks to their blurred edges and contrasting projecting and receding hues. He sought to heighten the impact of his works by exhibiting them in groups, and in 1958 he received a commission that seemed to be ideal, for a restaurant in the Seagram Building in New York. However, he eventually pulled out of the project and bequeathed a selection of these canvases, such as *Black on Maroon* (1958), to the Tate in London.

Other commissions, in the 1960s, were more successful. The murals for the Holyoke Center at Harvard University, completed in 1962, were followed by a collection of sombre paintings (1965–6) for the chapel in Houston founded by the philanthropists John and Dominique de Menil. Once again, the deep hues were intended to convey Rothko's tragic view of the human condition, as were some slightly later works in which the dark compositions are constricted by their white borders. Rothko's own physical and mental health was fragile, and in 1970 he committed suicide. It is tempting to interpret his last works as an expression of his psychological state, although the artist denied that this was his purpose.

SCHWITTERS
SPENCER

KURT
SCHWITTERS

GERMAN
1887–1948

The German artist Kurt Schwitters (born 1887, Hannover, Germany) created a huge range of works, from small-scale collages to complex interiors, made from everyday objects and detritus. His oeuvre intended to break down boundaries between art and normal life. However, it had a strong aesthetic quality, unlike other manifestations of the Dada movement in the period following World War I.

Schwitters spent the years immediately before 1914 as a student at the Kunstakademie in Dresden. After military service he moved from an Impressionist-like style to a more radical Expressionist art, until he fell under the influence of the Dada movement in Berlin. His output included not only visual collages but also evocative poetry made up of randomly chosen and overheard words. In 1919 he began to apply the term 'Merz' to his work after using a fragment of the printed word 'Kommerz' in one of his collages, but his media extended far beyond paper and card.

As Schwitters declared, 'a perambulator wheel, wire-netting, string and cotton wool are factors having equal rights with paint', and in his hands such materials were incorporated into beautiful, even tasteful compositions. Indeed, he was awarded the sobriquet 'the Caspar David Friedrich of the Dadaist Revolution'. This comparison to the German Romantic painter was not intended as a compliment, and Schwitters remained an artist who did not fit neatly into a single movement.

WHERE TO SEE SCHWITTERS'S WORK
- Centre Georges Pompidou, Paris
- Hatton Gallery, Newcastle upon Tyne
- Los Angeles County Museum of Art
- Museum of Modern Art, New York
- Sprengel Museum, Hannover
- Tate Modern, London

DID YOU KNOW?
Despite seeking asylum in Britain, Schwitters found English reservations irritating. He once said: 'You always talk very quietly in England, at least the middle classes do. If you talk loudly you count as "common", not a gentleman … The result is a typical English attitude. The English don't defend their ideas, because then they'd have to talk loudly.'

everything had bro
wn and new thing
made out of the
agments; and this
was like a revoluti
thin me, not as it v
it should have bee

MERZ

K.

S

Merzbild 1A. The Psychiatrist, oil and collage on canvas, 1919

Despite these comparisons, Schwitters was moving towards a far more rational idiom, the Constructivism espoused by Russian artists as well as by De Stijl in the West. He promoted this approach in his own *Merz* magazine (1923–32), while a rectilinear quality appeared in his design and advertising work, as well as in collages such as *Mz 252. Coloured Squares* (1921).

For all this formal rigour, a wilder quality characterized the 'Merzbau' that Schwitters began to construct in his Hannover home in 1923. Wooden and plaster grottoes created a confusing succession of spaces, housing a wide array of found objects and organic materials, including hair and the artist's own urine. The allocation of these treasures to special compartments completed their transformation into something aesthetic and almost transcendent.

With the rise of the Nazis, Schwitters began to be identified as a 'degenerate' artist, and in 1937 he left Germany, leaving the Merzbau unfinished. It was eventually destroyed in an Allied air-raid. Initially, Schwitters went to Norway but three years later he fled to Britain. After internment as an enemy alien on the Isle of Man, he lived in London and Cumbria, producing conventional portraits as well as continuing his Dada activity. His late collages include *En Morn* (1947), which anticipates Pop art in its humour and ephemeral imagery.

En Morn, collage on paper, 1947

STANLEY SPENCER

BRITISH
1891–1959

The paintings of Stanley Spencer (born 1891, Cookham, Berkshire, UK) are visionary images in which scenes of English life are endowed with an intense religious significance. A village high street is transformed into Jerusalem, and everyday reality, not to mention sexuality, becomes sacred.

Cookham served as the setting for many of his paintings as a kind of paradise. In 1908 he began four years of study at London's Slade School of Fine Art, where he developed the precise draughtsmanship that was to be the basis of all his work. After military service Spencer was appointed an Official War Artist in 1918 and he painted *Travoys Arriving with Wounded at a Dressing-station at Smol, Macedonia, September 1916* (1919), based on his experiences with the 68th Field Ambulance in Macedonia.

Spencer also produced images that are a kind of transfiguration of mundane activities, as in the radiant *Swan Upping at Cookham* (1915–19) and created Christian scenes, culminating in *The Resurrection, Cookham* (1924–7), which shows the artist and familiar figures rising from the dead in a setting inspired by John Donne, who described a churchyard as 'the holy suburb of Heaven'. Spencer's most remarkable version of Christian iconography was *The Resurrection of the Soldiers* (1927–32) in the Sandham Memorial Chapel in Burghclere, Hampshire. This oratory, built in memory of an officer who had died in

WHERE TO SEE SPENCER'S WORK

- Fitzwilliam Museum, Cambridge
- Imperial War Museum, London
- Leeds Art Gallery
- Sandham Memorial Chapel, Burghclere
- Stanley Spencer Gallery, Cookham
- Tate Britain, London

DID YOU KNOW?

Spencer was married twice. In 1937 he left his first wife, the painter Hilda Carline, for their neighbour Patricia Preece. Apparently, neither woman accepted his proposal of a *ménage à trois*. Patricia subsequently returned to her girlfriend while Spencer remained devoted to Hilda until her death in 1950.

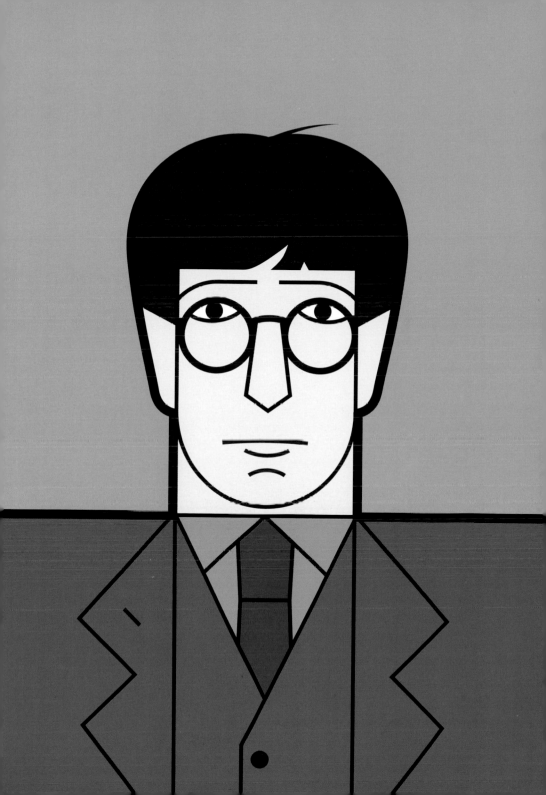

the Macedonian campaign, was decorated with a scheme inspired by the medieval painter Giotto. Yet, instead of depicting overtly Christian themes, Spencer covered the side walls with images illustrating the routines of military life. Washing, scrubbing, kit inspection, even the filling of tea urns, are represented with characteristic reverence.

Sex dominated Spencer's work in the 1930s. Some of his pictures refer to his tortuous erotic life; others, such as the various *Beatitudes of Love* (1937–8), express Spencer's belief in the sacred nature of human sexuality; all were meant to be displayed in the unrealized Cookham Church House, a temple to salvation through sex. As well as being unacceptably carnal, the works were alienating in style. The figures in the *Beatitudes* were highly distorted, while Spencer's eye for detail was taken to an extreme in paintings such as *Double Nude Portrait: The Artist and his Second Wife* (1937). The texture of flesh, both human and animal, invites comparison with later works by Lucian Freud, and was clearly too tough for Britain in the 1930s.

World War II came as an unlikely source of salvation, when, as in the previous conflict, Spencer was made an Official War Artist, this time by Kenneth Clark. As well as painting a series depicting the construction of warships on the Clyde (1940–6), Spencer also returned to the theme of Resurrection, exemplified by the monumental canvas *The Resurrection: Port Glasgow* (1947–50).

These artistic triumphs resulted in Spencer's rehabilitation into the Establishment during the 1950s. He made his peace with the Royal Academy, with which he had quarrelled in the 1930s, and received a knighthood and a retrospective at the Tate.

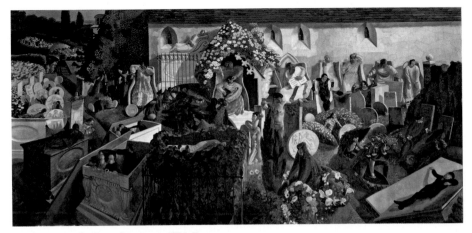

The Resurrection, Cookham, oil on canvas, 1924–7

TATLIN
TWOMBLY

VLADIMIR
TATLIN

RUSSIAN

1885–1953

The Constructivist Vladimir Tatlin (born 1885, Moscow, Russia) was a visionary artist associated with the Russian Revolution, although his influence waned when the Soviet government began to promote a more conservative Socialist Realism.

Vladimir Tatlin was brought up in Kharkiv, in eastern Ukraine, and was a cadet in the merchant navy before moving back to his birthplace. In Moscow he made a living from painting icons. The example of Russian religious art was an important counterbalance to the Western influences that he encountered at colleges in Moscow and Penza during the first decade of the 20th century. In the years leading up to World War I, Tatlin was close to Mikhail Larionov and his colleagues, who were developing a modernist style while maintaining a strong interest in traditional Russian art.

Tatlin's work at this time ranged from set and costume designs with a strong national flavour to works inspired by Pablo Picasso and Henri Matisse. These Western influences could be seen in the *Rhythmic Nudes* (1913) but were even stronger after Tatlin met Picasso in Paris in 1914. Following this encounter Tatlin began to experiment not only with Cubist paintings and collages that included writing but also with reliefs made from found objects. His lost *Corner Counter Relief* (1914–15) not only used unconventional media but also ignored the normal relationship between the artwork and the flat wall on which it was displayed.

WHERE TO SEE
TATLIN'S WORK

- Museum of Modern Art, New York
- State Russian Museum, St Petersburg
- Tretyakov Gallery, Moscow

DID YOU KNOW?

Around 1930 Tatlin invested considerable effort into developing the Letatlin air-cycle or glider. His research included the dissection of cranes' wings and experiments at the bell-tower of the Novodevichy Monastery in Moscow, but, although the invention was highly aesthetic, it never actually worked.

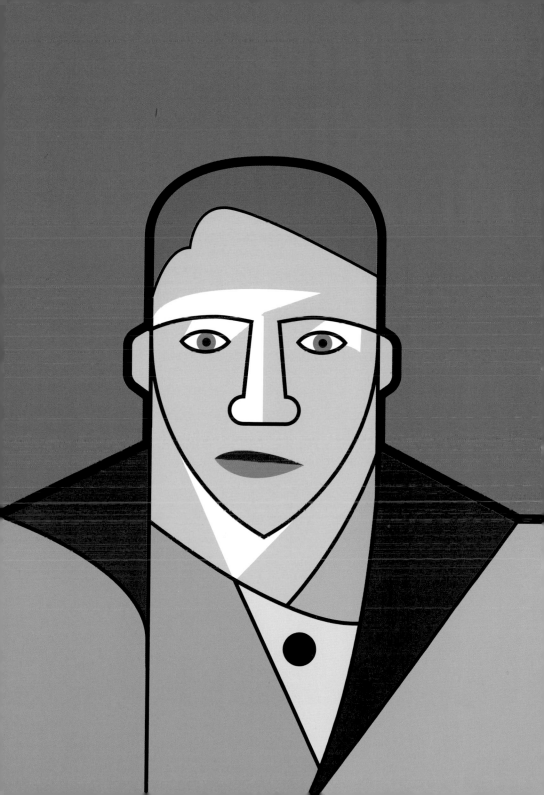

This emphasis on construction and materials, and disdain for individual forms of expression, put Tatlin in line with the artistic aims of the Soviet government following the October Revolution of 1917. Tatlin was given various administrative and teaching roles and, most famously, designed a wooden model for the *Monument to the Third International* in 1919–20. This prototype, subsequently destroyed, was to be the basis for a vast spiralling structure, based on an internal frame of girders, which was to house the new world government. Its axis was to point towards Polaris, or the Pole Star, as if to emphasize the building's visionary quality.

Tatlin's work in this period ranged from avant-garde theatre designs and performances to an array of design projects that were intended to be of practical use to the working man and woman. They included clothes, a stove, ceramics and ergonomic furniture, as well as numerous examples of the bandura, a stringed folk instrument of which Tatlin was extremely fond. However, after the apogee of his career in the early 1920s, politics turned against him. His Constructivist credentials marginalized him, and in his later career he withdrew into painting genres such as the still life.

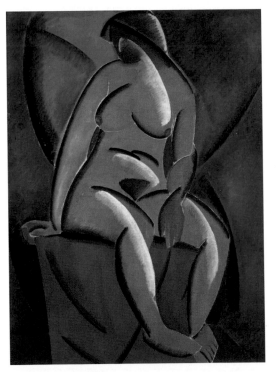

Nude, oil on canvas, 1913

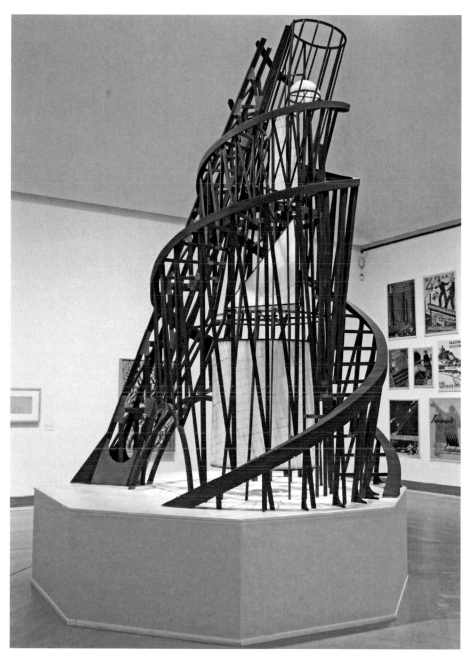

Monument to the Third International, reconstructed model in wood, metal and Falun red paint, 1919–20

CY
TWOMBLY

AMERICAN
1928–2011

Cy Twombly (born Edwin Parker Twombly, Jr, 1928, Lexington, Virginia, USA), an American painter who spent much of his life in Italy, drew heavily on antiquity for inspiration. His pictures refer to classical themes, while their intense colours, expressive brushwork and elements of graffiti give them a thoroughly modern appearance, although he distanced himself from the movement of Abstract Expressionism.

Twombly was known as 'Cy' after his father, who himself acquired the nickname in honour of the baseball player Cy Young. Trained in Boston, Twombly joined the Art Students League in New York in 1950, before spending time at the Black Mountain College in North Carolina. Even more important was the trip that he made to Italy and Morocco in 1952 with fellow artist Robert Rauschenberg, from which he returned with a sketchbook filled with motifs. Around this time he also began to experiment by working with his left hand or in the dark, practices that were intended to diminish his own control of his work. Inevitably, this gave his abstract paintings of this period a certain rawness, enhanced by the odd expletive written onto the canvas.

In 1957 Twombly returned to Italy in some style, acquiring both an aristocratic wife and a Roman palace, as well as spending time by the sea. Here he captured the 'white, white, white' quality of the Mediterranean in a series of remarkable drawings and paintings, which contrast dramatically with his lurid *Ferragosto* pictures, such

WHERE TO SEE
TWOMBLY'S WORK
- Cy Twombly Gallery, Menil Collection, Houston, Texas
- Hirshhorn Museum and Sculpture Garden, Smithsonian Institution, Washington, DC
- Museum Brandhorst, Munich
- Museum of Modern Art, New York
- Tate Modern, London

DID YOU KNOW?
Twombly's love of classical culture ranged from ancient poets such as Catullus and Sappho, whose writings appeared in some of his canvases, to the architecture of his hometown. He took great satisfaction from pointing out that the Lexington area has 'more columns…than in all ancient Rome and Greece'.

as *Ferragosto II* (1961). Twombly's career swung between poles of austerity and abandon, though, perhaps under the influence of Minimalism, it was blankness that characterized his work around 1970. This is particularly striking in the six monochrome canvases known as the *Treatise on the Veil* (*c.*1968–70).

From the mid-1970s, however, a certain richness reappeared, with the creation of sculptures that evoked classical antiquity and pictures that were both liquid and luminous. This tendency reached its climax in the 1980s, for example in *Untitled (A Painting in Nine Parts)* (1988) inspired by Venice and now in the Menil Collection, Houston. Other works, such as the two series of *The Four Seasons* made between 1993 and 1995, also display a rich sensuality as well as having an allegorical meaning concerned with the stages of life. In contrast, ten years later Twombly reacted to the Iraq War (2003–11) with canvases dominated by horrific arcs of blood-red paint. For someone who was so preoccupied with the culture of the past, Twombly maintained a firm grip on the realities of the present.

Winter, oil, house paint, pencil and crayon on canvas, 1993–4

UTRILLO

MAURICE
UTRILLO

FRENCH
1883–1955

An untrained artist, Maurice Utrillo (born 1883, Paris, France) created some memorable views of Paris, especially in the years before World War I. He was encouraged by his mother, the painter Suzanne Valadon, and, despite an addiction to alcohol, achieved international renown. In 1950 he represented France at the Venice Biennale.

Utrillo was a native of the bohemian Parisian quarter of Montmartre, speaking with the distinctive accent of the 18th arrondissement. He was adopted by his mother's friend, the Catalan journalist Miguel Utrillo, but often signed himself 'Valadon'. His natural father is not known for sure, although the painters Pierre Puvis de Chavannes and Pierre-Auguste Renoir, and even Miguel Utrillo himself, have been suggested. As a youth, Maurice already suffered from alcoholism and this led his mother to push him towards painting as a more positive influence. This early example of art therapy did not cure his addiction but eventually led to a successful career.

Like the Impressionists before him, Utrillo painted the greenery and smoking chimneys of the suburban hinterlands of Paris. Although influenced by Camille Pissarro and Alfred Sisley, his work has richer impasto sometimes applied with a palette knife, and makes more use of black as in *Rue Saint-Rustique* (*c.*1920).

Utrillo was also a fine draughtsman with a strong sense of line, as can be seen in the architectural paintings exemplified by *Bayonne Cathedral* (1915). While his acclaimed

WHERE TO SEE UTRILLO'S WORK
- Centre Georges Pompidou, Paris
- Kunstmuseum, Bern
- Metropolitan Museum of Art, New York
- Musée de l'Orangerie, Paris
- Museum of Fine Arts, Boston

DID YOU KNOW?
Utrillo painted many of his paintings from memory or from postcards. While some people criticized him for this, his mother Suzanne Valadon leapt to his defence: 'From picture postcards my son has made masterpieces; others fancy that they are creating masterpieces when they are merely turning out picture postcards.'

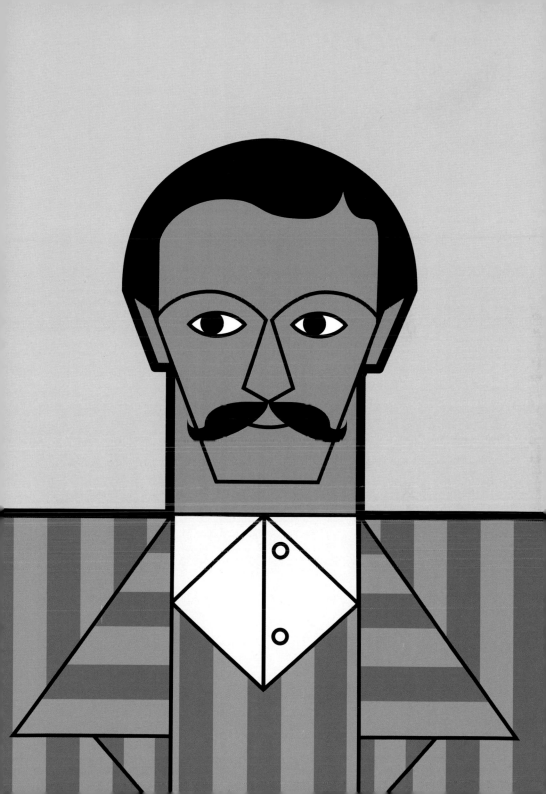

'white period' saw him focus on subdued, chalky tones, he later evolved into a vibrant colourist and these attractive later works commanded high prices. *Street Scene* (1924) is vivacious, evoking the effect of bright sunshine after rain, and yet it was painted close to the time when Utrillo tried to kill himself in a police cell.

Although Utrillo suffered from alcoholism throughout his life, was confined to an asylum and was overbearingly controlled by his family, he did, later on, find a measure of order in his marriage. *The Birthplace of Joan of Arc* (1935) combines the solaces of sainthood with an inscription 'A ma chère femme Lucie'.

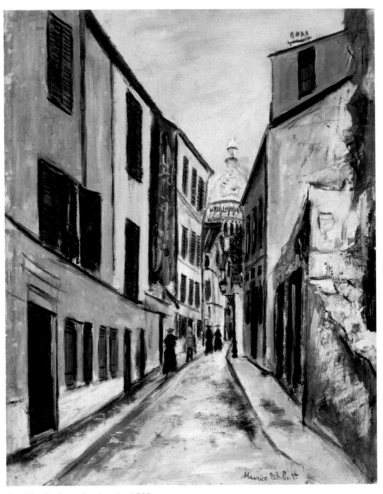

Rue Saint-Rustique, oil on board, *c.*1920

VIOLA

BILL
VIOLA

AMERICAN
BORN 1951

The American video artist Bill Viola (born 1951, New York, USA) has used technology to confront universal experiences and metaphysical issues, often with more than a nod to the great art of the past. Buddhism, Christianity and Sufism have all been thrown into the mix, creating engrossing images and narratives.

Viola graduated from Syracuse University in 1973, when he began to make experimental music with David Tudor and Composers Inside Electronics, which he continued until 1980. An early installation, *He Weeps for You* (1976), used closed-circuit television to include the filmed viewer in the work. The key image – a reflection of the gallery visitor in a drop of water – clearly showed off his penchant for the iconic.

Viola's works were often made in collaboration with his wife, Kira Perov. *Heaven and Earth* (1992) emphasized the interaction between the two components of the installation, a monitor with video footage of an old woman on the verge of death facing another showing a newborn baby. The juxtaposition was made more intense by the location of the screens, which were so close that reflections of the images they displayed were seen in each other, as life and death reflect and contain each other. This theme of life and death is continued in *Nantes Triptych* (1992).

In this period Viola's works took on something of the format and imagery of late medieval or Renaissance altarpieces. Examples of this tendency include

WHERE TO SEE
VIOLA'S WORK
- Centre Georges Pompidou, Paris
- Kunstmuseum, Basel
- Museum of Contemporary Art, San Diego
- Tate Modern, London
- Whitney Museum of American Art, New York

DID YOU KNOW?
Viola learned ink painting and meditation with the Zen master Daien Tanaka. This helped him to see 'the sense of an object' and had a direct influence on his video art. 'I have sensed…that intense unrelenting camera vision can be compared to concentrated vision, which heralds a shift in consciousness… The object doesn't change, you do.'

194

The Greeting, video/sound installation, 1995

The Greeting (1995), which was a video installation of three women meeting. This secular version of the Christian theme of the Visitation, derived from a painting by Jacopo da Pontormo, was followed by *The Passions*, another work based on devotional art, exhibited in 2003. The use of slow motion in these projects, together with their allusions to sacred imagery, can seem a bit portentous. However, there is no doubt that Viola's work engages with fundamental emotions and experiences, often by juxtaposing them with their opposites.

The theatrical quality of Viola's installations made them ideal for the stage, and in 2004 he produced video sequences to accompany a production of Wagner's opera *Tristan and Isolde*. As well as being projected as a backdrop in various performances, Viola's installations were also displayed without musical accompaniment in two venues in London. This showing of the films emphasized the universal significance of Viola's images beyond the world of fine art, with their elemental and ritualistic qualities.

Nantes Triptych, video/sound installation, 1992

WARHOL
WHITELEY

ANDY
WARHOL

AMERICAN

1928–86

With his bleached-blond hair and impassive expression, Andy Warhol (born 1928, Pittsburgh, Pennsylvania, USA) epitomized the 1960s cool of Pop art. He managed to keep this going even after the swinging decade had passed away and in the 1980s he perfectly reflected the era's cult of money and celebrity. Warhol left behind a body of work that was based on popular imagery but knocked at the gates of high culture, however casual were his pronouncements on art.

Andrew Warhola was born to Czech immigrant parents in Pittsburgh, where he trained at the Carnegie Institute of Technology before moving to New York in 1949. His experience as a commercial artist making magazine illustrations prepared him for the Pop art that he produced in the early 1960s, including his acrylic and graphite *Big Campbell's Soup Can (19¢)* (1962). Warhol also reproduced this and other products with their distinctive packaging in painted wood, blurring the boundaries between traditional sculpture and ubiquitous consumer culture.

The most distinctive contribution that Warhol made to Pop art was his use of silkscreen prints to transform photographs of film stars. In *Four Marilyns* (1962), Monroe's familiar features appear numerous times in brightly inked hues. Despite the apparent repetition, the various representations of the actress's face are slightly different from their neighbours, so that the work as a whole defies conventional distinctions

WHERE TO SEE WARHOL'S WORK

- Andy Warhol Museum, Pittsburgh, Pennsylvania
- Los Angeles County Museum of Art
- Menil Collection, Houston, Texas
- Museum Brandhorst, Munich
- Museum Ludwig, Cologne
- Tate Modern, London

DID YOU KNOW?

Warhol surrounded himself with a clique of counter-culture figures in his Manhattan workshop known as The Factory, where assistants produced his silkscreen images. One of this coterie, the radical feminist Valerie Solanas, famously shot Warhol in 1968. He survived his injuries, to die many years later from complications following a gall-bladder operation.

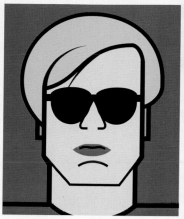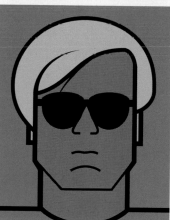

Campbell's Soup Can, acrylic on canvas, 1962

between unique 'high' art and popular mass-produced imagery.

Warhol employed this approach not only for pictures of Elizabeth Taylor, Marlon Brando and Elvis but also in the silkscreens entitled *Disasters*. This lurid series reused sensational headlines from newspapers together with photographs of the electric chair, a car crash or a race riot. No theme was too trivial or too tragic for the Warhol treatment, which, just like the mass media, was indiscriminate in its repetition and dissemination of images.

Like Marcel Duchamp before him, Warhol mocked the cult of the unique work of art through reproductions of the works of Leonardo da Vinci, as in *Double Mona Lisa* (1963), as well as producing 'Do It Yourself' painting-by-number pictures. However, nothing expresses more vividly the death of the author than the eight-hour film *Empire* showing a single view of the Empire State Building, which was shot, without any intervention from the director, over six hours one summer night in 1964, and played at a slower speed to make it more 'unwatchable'.

The 1970s were marked by numerous silkscreen portraits, generally slick commissions from the rich and famous, though at the end of the decade Warhol undertook some more ambitious projects. These ranged from an installation of prints based on a photograph of a shadow to abstract patterns made by urinating on canvases covered with copper paint – another challenge to traditional concepts of artistic creation.

In his final years Warhol was associated with a younger generation of artists, some of whom, like Jean-Michel Basquiat and Keith Haring, collaborated with him and barely outlived him. After his death, Warhol's imagery was taken up and often subverted by the artist Deborah Kass.

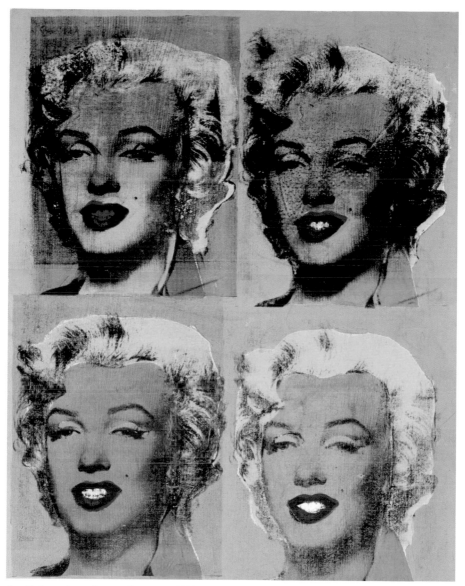

Four Marilyns, polymer silkscreened on canvas, 1962

BRETT
WHITELEY

AUSTRALIAN
1939–92

Brett Whiteley (born 1939, Sydney, Australia) was one of the most successful artists to have emerged from Australia. He travelled widely, making paintings with exciting colours and linear designs, in which he sought to balance 'the forces of abstraction, realism and expressionism'.

Whiteley developed an early enthusiasm for art after seeing reproductions of works by Vincent van Gogh. In the late 1950s he went to night classes in drawing at the Julian Ashton Art School. While making his living from working for an advertising agency, he also produced atmospheric figurative oil paintings such as *Terrace Houses* (1956). In 1960 he was awarded a travelling scholarship to Italy. He developed a more abstract style influenced by English artists such as Roger Hilton, and in 1961, the year in which he moved to London, the Tate Gallery bought the recently executed *Untitled Red Painting* (1960).

He did not, however, abandon figurative art, and in the 1960s he worked with great success in traditional genres such as still life, landscape and the nude. His pictures of his wife, Wendy Julius, in the bath show his ability to work in varying degrees of naturalism and abstraction. By 1964 a darker tone had appeared in a series of works about the serial killer John Christie, who had committed his crimes close to Whiteley's lodgings in west London.

WHERE TO SEE WHITELEY'S WORK

- Art Gallery of New South Wales, Sydney
- Brett Whiteley Studio, Surry Hills, Sydney
- Metropolitan Museum of Art, New York
- Newcastle City Art Gallery, New South Wales
- Tate Modern, London

DID YOU KNOW?

Clive James's memoir *Falling towards England* (1985) has a memorable passage about a painter named Dibbs Buckley, described as 'incomparably the most successful young Australian expatriate', and his wife, Delish, 'a Van Eyck angel in jeans and T-shirt'. It is widely speculated that Dibbs Buckley is based on Whiteley.

After Whiteley won a scholarship in 1967 to study and work in New York, he began to work on a monumental scale, using multiple wood panels and enriching the texture of the paint with the addition of photographs, fibreglass and other forms of collage. This turbulent period, in which he was heavily involved with protests against the Vietnam War (1954–75), was followed by a year in Fiji before his return to Australia in 1969. Such works as *Listening to Nature* (*c.*1967), with its heavy impasto and tumultuous mood, highlight a productive period of experimentation with materials.

While paintings such as *Alchemy* (1972–3), a modified version of which appeared on the cover of a Dire Straits album, could be seen as esoteric self-portraits, other works of this period are more straightforward celebrations of the landscape and light of Australia. A field of bright paint floods *Big Orange (Sunset)* (1974), which is animated by suggestive flecks and licks of different colours. The warmth of the painting is set off by its companion sculpture, *(Free standing ultramarine) Palm Trees* (1974), a fibreglass palm-tree in ultramarine blue, one of Whiteley's favourite hues. His works straddled the boundaries between figuration and abstraction and were extremely emotive and experimental. For all the vitality of his work, Whiteley was heavily dependent on drugs and alcohol, which he regarded as liberating his creativity. He died from a heroin overdose in a New South Wales motel.

Big Orange (Sunset), oil and collage on wood, 1974

ZHANG
XIAOGANG

CHINESE
BORN 1958

This artist's distinctive formula, imitating the idiom of old studio photographs, has produced some of the most famous works from contemporary China. While the images are somewhat repetitive, this is actually part of the point – they express the conformism of Chinese society while allowing hints of individuality to glimmer through the greyness.

Zhang Xiaogang (born 1958, Kunming, Yunnan, China) grew up during the upheavals of the Cultural Revolution (1966–76), in which both his parents were sent away for re-education. From 1977 to 1982 he trained at the Sichuan Institute of Fine Arts in Chongqing, where teaching was still dominated by the doctrine of Socialist Realism, a figurative style designed to emphasize the strength of the Socialist state and the heroism of the worker. Zhang's own early work included landscapes influenced by 19th-century French painting, and it was a long time before he developed a more distinctive idiom. After a period of great personal difficulty, in 1992 he experienced a kind of epiphany during a visit to Germany, which led him to re-evaluate his national and personal identity.

Zhang lives in Beijing, where he has produced an extremely successful body of work comprised mainly of monochrome images of people who seem to be linked by traditional family and social bonds. In the *Bloodline: Big Family* series, for example

WHERE TO SEE
XIAOGANG'S WORK

- Art Gallery of New South Wales, Sydney
- National Gallery of Australia, Canberra
- Queensland Art Gallery, Brisbane
- Shenzhen Art Museum

DID YOU KNOW?

Zhang family photographs have been a vital source of motivation for the artist. The *Bloodline: Big Family* series in particular was inspired by his discovery of a photograph of his mother as a young woman, in which she seemed quite different from the troubled woman that he remembered.

Bloodline: Big Family, No. 2, oil on canvas, 1995

Three Comrades (1994) and *No.2* (1995), a thread of red paint recurs as if to unite the characters into one whole. The sense of kinship is strengthened by the frighteningly similar appearance of the people in his paintings. Men and women have an androgynous quality, while their enlarged heads, long noses and tiny hands give them a faint air of the grotesque. They are plainly dressed and uniformly impassive, with formal, static poses, more like mannequins than human beings.

For all this apparent homogeneity, the artist's relationship to his characters varies considerably. Some of them are seen from close up, as if under intense scrutiny, while others appear almost in full-figure poses. *My Dream: Little General* (2005) shows most of a boy's body, his upper half dressed in military uniform while from the waist down he is totally naked. In its bizarre juxtaposition the image is both heroic and ridiculous, suggesting a contrast between the public and private, persona and personality. Most significantly, the face is marked by a flash of colour like a stain in an old photograph. In this way, assertions of identity – minor mutinies against convention – are hinted at, though never actually realised.

The technique that Zhang uses to create his paintings renders his subjects even more anonymous, using a soft focus and a pale patina to ensure that any identifying features are obliterated. With their glassy eyes and expressionless faces, his subjects look brainwashed and mute, exhausted by the pursuit of an idealistic dream that never materializes.

JIRŌ
YOSHIHARA

JAPANESE
1905–72

Jirō Yoshihara (born 1905, Osaka, Japan) played a seminal role in the Japanese avant-garde during the post-war period. As a founder of the Gutai group in 1954, he developed a radical approach towards abstract painting and performance art, which he publicized internationally with great aplomb.

Born into an affluent merchant family, as a young artist Yoshihara went through a succession of Western styles, partly under the influence of the painter Jirō Kamiyama, who had just returned from Paris. Starting with the example of Paul Cézanne, Yoshihara moved from Post-Impressionism through Fauvism to Surrealism and geometric abstraction. An untitled work of about 1936 in the Museum of Modern Art, Kamakura & Hayama, is characterized by non-figurative shapes, a restrained palette and floating constructions without perspective, arranged on a white background.

With wealth inherited from the family's cooking oil business, Yoshihara was able to play a key role in reviving the Japanese avant-garde after World War II, and in 1954 he financed the Gutai group in Osaka. The founder members included his student Shozo Shimamoto as well as fellow performance artists Saburo Murakami and Kazuo Shiraga.

Yoshihara's own gestural, textured works, such as *White Painting* (1958), were clearly influenced by Western expressive abstraction. However, he was keen to point

WHERE TO SEE
YOSHIHARA'S WORK
- Ashiya City Museum of Art & History
- Carnegie Museum of Art,
 Pittsburgh, Pennsylvania
- Fukuoka Art Museum
- Museum of Modern Art,
 Kamakura & Hayama
- National Museum of Modern Art,
 Tokyo

DID YOU KNOW?
As the leader of Gutai, Yoshihara ensured that the group was not copying European art. He even instructed his student (and co-founder of Gutai) Shimamoto to stop piercing his paintings as they might be seen as imitations of the Italian artist Lucio Fontana's slashed canvases. In fact, Shimamoto had made them before he saw Fontana's work.

out, in the group's manifesto of 1956, that gutai meant 'concreteness' rather than pure subjectivity. Like his colleagues, Yoshihara placed particular emphasis on the physical activity of art. In the same year he injected an interactive element into an exhibition by setting up *Please Draw Freely* (1956), a board on which children and other spectators were encouraged to scribble. Other events had a more elevated tone, as in the *International Sky Festival* of 1960, when art from both Japan and abroad was suspended from white balloons floating in the sky.

Although Yoshihara was a pioneer of avant-garde art in Japan, his work was always rooted in indigenous Japanese traditions. Together with Shiryu Morita, he practised an avant-garde version of calligraphy and produced a series of *En* (*Circle*) pictures inspired by Zen Buddhism. *White Circle* (1970) exemplifies his approach, in which the background is painted so that the central form is represented by the bare canvas. Yoshihara dedicated the final decade of his life to these paintings, some of which were made with the monochrome palette of traditional calligraphy, while others had vibrant colour combinations evoking Abstract Expressionism. Despite the apparent repetition of forms, each of the shapes in the circle paintings is unique and Yoshihara repeatedly argued that he was not satisfied with any of them. Yet these works (many of which are named *Work*) perfectly embody a meditative approach, in stark contrast to the dynamism of Gutai's happenings and performances.

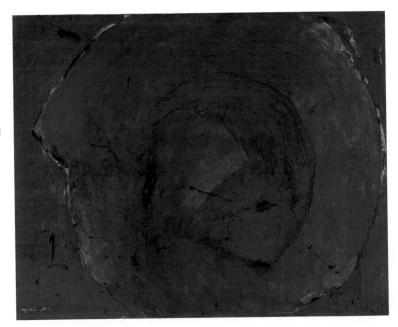

Work, oil on canvas, 1965

LARRY ZOX

AMERICAN

1937–2006

Larry Zox (born 1937, Des Moines, Iowa, USA) exemplified the shift in American abstract art from expressive, irregular forms to a more hard-edged style. His pictures are made up of planes of colour, often spliced in two (or three) so that the sections seem to be slipping away from each other, as in *Orange Time* (1965). A renowned colourist, his exuberant, geometric compositions represent a range of physical phenomena without conveying any obvious emotion.

Zox was educated at the University of Oklahoma and Drake University before studying under George Grosz at the Des Moines Art Center. After moving to New York in 1958, he created collages from pieces of painted paper that were stapled onto plywood. The ragged, expressive edges visible in these early works were gradually replaced by straighter, more impersonal lines. In 1963 he began his *Rotation* series, in which a standard geometrical composition was repeated in various paintings with different colour schemes.

Although Zox abandoned collage for works made solely with paint, he occasionally worked out the compositions for these paintings by using reliefs made from plywood and Perspex. Areas of white, for example in the triangular shapes at the edge of the canvas, reflected the notches and empty spaces in his three-dimensional work. In the 1970s he began to reintroduce a softer, irregular quality to his paintings, using

WHERE TO SEE ZOX'S WORK

- Museum of Modern Art, New York
- Hirshhorn Museum and Sculpture Garden, Smithsonian Institution, Washington, DC
- National Gallery of Art, Washington, DC
- Tate Modern, London
- Whitney Museum of American Art, New York

DID YOU KNOW?

In the 1970s Zox's studio on 20th Street in New York was famous as a rendezvous for artists, boxers and bikers. He was also a regular at Max's Kansas City nightclub in Manhattan. Later, he had a change of scene, becoming an artist-in-residence at Ivy League universities such as Dartmouth and Yale.

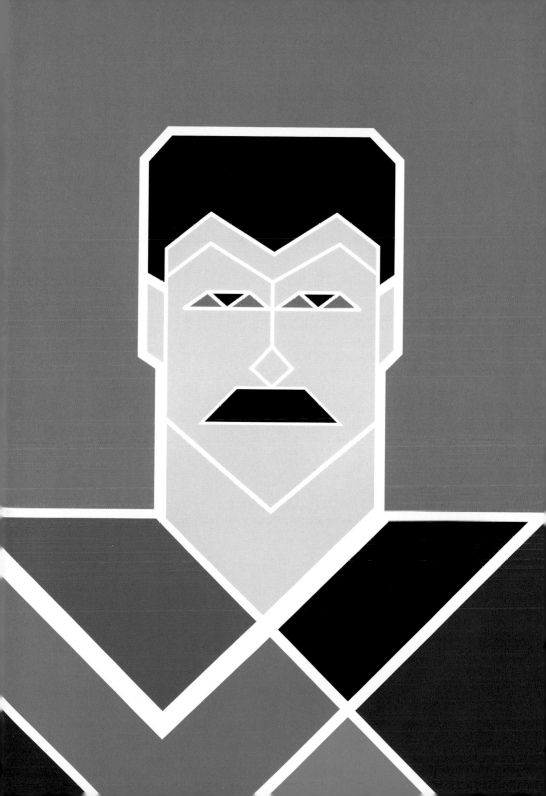

Rotation B, acrylic on canvas, 1964

asymmetrical shapes and uneven washes of colour. Throughout his career, however, he remained interested above all in strong physical effects – sensations of shifting and buckling, bending and overlapping – with which he playfully manipulated the two-dimensional picture surface in works including *Gemini Series 1* (1968).

Gemini Series 1, acrylic on canvas, 1968

GLOSSARY

Abstract Expressionism Painting movement, predominantly American, that gained international renown in the 1940s and 1950s. The term applies to a wide range of abstract styles with strong emotional or expressive content.

Abstraction-Création Group of artists, formed in Paris in 1931, dedicated to the development of non-figurative art. Held regular group exhibitions until 1936.

Analytical Cubism Phase of Cubism (1908–12), characterized by fragmented forms, multiple viewpoints, and a largely monochrome palette. See also *Synthetic Cubism*.

Apollonian Relating to the Greek god Apollo, seen to represent reason, logic and restraint. See also *Bacchic*.

Art Students League Art school in New York City, founded in 1875 and known for its informal approach. The students' work is not graded and the school does not award degrees.

Automatism The practice of making art, apparently without any conscious control, by using procedures that combined an element of chance with free association (see *Decalcomania*, *Frottage* and *Grattage*). This approach is associated with Surrealism and was influenced by Sigmund Freud's exploration of the unconscious.

Bacchic Relating to the ancient god Bacchus, associated with frenzy and intoxication. See also *Apollonian*.

Bauhaus Influential German school of art, design and architecture. Active from 1919 until 1933.

Ben-day Method of printing used in comic books, in which individual dots are used to create a picture.

Black Mountain College Influential college in North Carolina, USA, active from 1933 to 1957. Known for its interdisciplinary and experimental approach to teaching.

Cercle et Carré (Circle and Square) Group of abstract artists, founded in Paris, which was succeeded by Abstraction-Création on its formation in 1931.

Chacmool Pre-Columbian Mesoamerican sculpture characterized by bulky, reclining figures with the head at a right angle to the body.

Color Field Painting Abstract movement of the 1950s and 1960s, characterized by large, flat areas of colour.

Constructivism Abstract movement inspired by modern industry and associated primarily with Soviet Russian artists such as Vladimir Tatlin.

Cubism Highly influential avant-garde style, developed by Pablo Picasso and Georges Braque in the period leading up to World War I, consisting of fragmented forms, as if viewed from different perspectives.

Dada Anti-war, left-wing movement encompassing the visual arts, poetry and performance, founded in Zurich during World War I, with manifestations in other European cities and New York. It undermined traditional concepts of art and the artist, and played a vital role in the inception of Surrealism.

Decalcomania Technique of transferring a painting onto another surface by either folding or pressing onto a new surface. Used as part of the process of *automatism*.

De Stijl Dutch group of abstract artists, founded in 1917, which promoted a strict geometric approach to composition. Also published a journal of the same name until 1932. See also *Neo-Plasticism*.

Divisionism Painting technique, developed in the late 19th century, based on the principle that intense colour effects could be made by juxtaposing patches of contrasting hues, which would then merge in the eye. See also *Pointillism*.

Documenta Highly influential international contemporary art exhibition (founded 1955), held in Kassel every five years.

Ecole de Paris Broad group of international artists who gravitated towards Paris from around 1900 to 1940, when the city was known as the centre of Western art.

Existentialism Influential philosophical movement that concentrated on the existence of the individual in a universe

regarded as fundamentally meaningless and unfathomable.

Expressionism Broad term for art representing the artist's inner feelings, typically with vivid colours and free brushwork.

Fauvism French movement (c.1904–08) characterized by simplified forms, use of non-naturalistic colours and spontaneous painting. From the French word 'fauves' meaning 'wild beasts'.

Frottage Technique developed by Max Ernst whereby paper placed over a textured surface is rubbed with a pencil or other drawing material. From the French for 'rubbing'.

Futurism Italian movement, begun 1909, which included literature, sculpture, painting, photography and architecture. Expressed the dynamism and excitement of modern life.

Grattage Technique invented by Max Ernst whereby oil paint is scraped off a canvas while on a textured surface, in order to reveal the patterns beneath. From the French for 'scraping'.

Happening Artistic event or performance, without a narrative structure or text, which often involves audience participation or interaction.

Impressionism Nineteenth-century French art movement, beginning in the late 1860s, characterized by an emphasis on modern subject-matter, informal compositions and bright colours. Studio work was combined with painting outdoors, which encouraged a sketchy, luminous style.

Khartoum School Group of artists in Sudan, led by Ibrahim El-Salahi from the late 1950s onwards. One of the major modern art movements in Africa, taking inspiration from modernism and pan-African sources.

Masonite Hardboard, made from wood fibres, with a smooth surface, used for painting.

Minimalism Artistic movement, originating in the 1950s, characterized by austere geometric forms and a denial of individual expression. The works were often made with industrial materials.

Modernism Movement across art, architecture and design, largely a phenomenon of the 20th century. It rejected the past and sought to create a new, highly formal aesthetic for the modern world.

Neo-Plasticism Artistic idiom associated with De Stijl and, above all, the work of Piet Mondrian. The term applies to abstract painting using only primary colours, black, white and grey, with compositions based on rectangles and horizontal and vertical lines. See also *De Stijl*.

Neo-Romanticism Style of painting, often inspired by the British landscape in the years around World War II. Also refers to a strand of figurative painting in Paris in the early 1920s.

Papier collé Technique pioneered by Georges Braque and Pablo Picasso, which combined drawing with collage using different types of paper. From the French for 'pasted paper'.

Pointillism A form of divisionism in which painters would exclusively use dots of bright, contrasting colours.

Pop art International movement, originating in the 1950s, which took inspiration from the visual language of popular culture and advertising.

Post-Impressionism A term used to denote a variety of styles developed by artists (primarily Paul Cézanne, Paul Gauguin, Georges Seurat and Vincent van Gogh) following the final Impressionist exhibition of 1886.

Pre-Columbian Refers to all cultures in North, Central and South America prior to European colonization.

Seven and Five Society British group of artists, founded in 1919, initially advocating non-academic but figurative art. The inclusion of Ben Nicholson in 1924 paved the way for the membership of other abstract artists, and by the mid 1930s the group had effectively metamorphosed into a movement promoting abstraction.

Suprematism A form of abstract painting, launched by Kasimir Malevich in 1915, consisting of geometric forms, usually floating on a white background.

Surrealism Artistic and literary movement, founded by André Breton in 1924, that encouraged the use of the unconscious and was influenced by Sigmund Freud's theory of psychoanalysis. It included dream-like imagery and works created by techniques associated with automatism.

Synthetic Cubism Phase of Cubism, from 1912 onwards, distinguished by a wide range of colours, lucid compositions and the introduction of collage and different textures into paintings. See also *Analytical Cubism*.

Unit One British group of artists and architects, formed in 1933, embracing a variety of modern movements, including abstraction and surrealism. It held only one group exhibition.

INDEX

Page numbers in *italics* refer
to illustrations

Abstract Expressionism 10, 26, 86, 90, 114,
116, 158, 160, 170, 186, 212
Abstraction-Création 137, 142
Al Hurufiyya 56
Albers, Josef 10–12
 Adobes 12
 Homage to the Square 12, *12*
 Variant: Brown, Ochre, Yellow 12
Arp, Jean (Hans) 138
Bacon, Francis 14–17, 92
 Portrait of George Talking 17
 Study 8 for Pope Innocent X 16
 Three Figures and a Portrait 16
 *Three Studies for Figures at the Base of a
 Crucifixion* 14
Basquiat, Jean-Michel 18–21, 200
Self-Portrait as a Heel 21
2 Hours of Chinese Food 20
Bauhaus 10–11, 101, 104
Benton, Thomas Hart 158
Beuys, Joseph 22–5
 documenta 7 25
 Fat Chair 22
 Fat Felt Sculpture 22, 25
 Fettraum (Fat Room) 22, *24*
 How to Explain Pictures to a Dead Hare 25
Böcklin, Arnold 38
Bouguereau, William-Adolphe 122
Bourdelle, Emile-Antoine 66
Bourgeois, Louise 26–9
 I Do, I Undo and I Redo 28
 In and Out 28
 Maman 28, *29*
 Sleeping Figure 26
Bowery, Leigh 64
Brâncuși, Constantin 66, 130
Braque, Georges 30–2, 76, 110, 154, 156
 The Daily Paper 32, *32*
 Houses at L'Estaque 30
 Olive Tree near L'Estaque 30
 The Portuguese 30
 Studio series 32

Breton, André 46
Buñuel, Luis 46
Carline, Hilda 178
Carrà, Carlo 40
Cercle et Carré 137
Cézanne, Paul 30, 110, 130, 210
Chagall, Marc 34–7, 217
 The Fiddler 34
 The Walk 36
 The White Crucifixion 36, *37*
Chirico, Giorgio de 38–41, 58, 118
 Ariadne 40, *40*
 Squares of Italy (Piazze d'Italia) 38
 Two Masks 41
Choucair, Saloua Raouda 42–4
Composition in Blue Module 44, *44*
 Interforms 44
 Les Peintres cèlèbres 42
 Paris-Beirut 42
 Poem Wall 44
 Water Lens 44
Clark, Kenneth 148, 180
classicism 40, 156
Colour Field Painting 170
Constructivism 101, 104, 118, 166, 168,
177, 182, 184
Contemporary Art Society 146
Cubism 14, 46, 50, 52, 58, 66, 82, 118,
126, 134, 142, 145, 158, 182
and Picasso 30, 32, 76, 110, 124, 154,
156, 157
Dada movement 50, 58, 174, 177
Dalí, Salvador 46–9, 68
 Christ of St John of the Cross 46
 *Declaration of the Independence of the
 Imagination and the Rights of Man to his
 own Madness* 49
 Diary of a Genius 49
 Hidden Faces 49
 The Invisible Man 48, 49
 Lobster Telephone 49
 Mae West's Lips Sofa 49
 The Persistence of Memory 49
 Un chien andalou 46
 The Visible Woman 49

De Stijl 134, 136, 177
Delacroix, Eugène 125
Delaunay, Robert 102, 113
Demuth, Charles 88
Der Blaue Reiter 100, 102
Derain, André 30, 122
Diaz, Al 18
Doesburg, Theo van 136
Domínguez, Óscar 60
Duchamp, Marcel 50–2, 200
 The Bicycle Wheel 52
 *The Bride Stripped Bare by Her Bachelors,
 Even* 52
 Fountain 52, *52*
 *Given: 1. The Waterfall, 2. The Illuminating
 Gas* 52
 Nude Descending a Staircase *No.2* 50
Dyer, George 16
El-Salahi, Ibrahim 54–6
Brothel 54, 56
Reborn Sounds of Childhood Dreams 56, *57*
'The Tree' series 56
Vision of the Tomb 56
Emin, Tracey 162
Ernst, Max 58–60
 The Barbarians 60
 Celebes 58, *60*
 Europe after the Rain II 60
 The Great Forest 58
 La Femme 100 têtes 60
 Pietà or Revolution by Night 58
Expressionism 170, 174
see also Abstract Expressionism; German
Expressionism
Fauvism 30, 50, 110, 114, 120, 122, 124,
126, 210
Fontana, Lucio 210
Freud, Lucian 62–4, 92, 180
 Interior in Paddington 62, 64
 Nude with Leg Up 64
 Portrait of the Hound 64
 Queen Elizabeth II 64
 Two Plants 64
Freud, Sigmund 58, 120
Futurism 50, 118

Gabo, Naum 144
Gaudí, Antoni 116
German Expressionism 58
Giacometti, Alberto 8, 66–8, 138
 The Artist's Mother 68
 The Palace at 4am 68
 Spoon Woman 66
 Suspended Ball 66
 Three Men Walking II 68, *68*
 Walking Man I 68
 Woman with Her Throat Cut 66
Giotto 180
Grosz, George 62, 214
Gutai group 210, 212
Hamilton, Juan 152
Hamilton, Richard 52
Haring, Keith 200
Hébuterne, Jeanne 132, *133*
Hepworth, Barbara 70–3, 142, 144, 145
 Cantate Domino 73
 Forms in Echelon 70
 Four-square Walk Through 73
 Pierced Form 72, 73
 Spring 73, *73*
 Winged Figure 73
Heron, Patrick 144
Hirst, Damien 162, 164
Hockney, David 74–7
 A Bigger Splash I 74
 Bigger Trees near Warter 74, *76–7*, 77
 Mr and Mrs Clark and Percy 74
 We Two Boys Together Clinging 74
Hopper, Edward 78–81
 Cape Cod Sunset 78
 House by the Railroad 78
 Morning in a City 81
 Nighthawks 80, *80–1*
 Western Motel 81
Husain, Maqbool Fida 82–4
 Bharatmata (Mother India) 84
 Gaja Gamini 84
 Kalyani Kutty 84
 Through the Eyes of a Painter 82
Impressionism 46, 50, 78, 98, 110, 118, 122, 134
Indiana, Robert 86–8
 Afghanistan 88
 The Demuth American Dream No.5 88, *88*
 Eat/Die 88
 Love 88
 Mother and Father 86
 Peace series 88
Johns, Jasper 90–2
Between the Clock and the Bed 92

Mona Lisa 92
Painted Bronze 92
Regrets series 92
Three Flags 90, 92
Kahlo, Frida 94–7
 Marxism Will Give Health to the Sick 94
 Self-Portrait on the Borderline between Mexico and the United States 94
 Self-Portrait with Cropped Hair 96, *97*
 Self-Portrait with a Monkey 96
Kamiyama, Jiro 210
Kandinsky, Wassily 98–101, 102
 Composition 8 100–1, 101
 Concerning the Spiritual in Art 100
 Painting with White Border 100
Kass, Deborah 200
Kelly, Ellsworth 86
Khartoum School 54, 56
Klee, Paul 102–5
 Catastrophe in a Dream 104
 Memorial to the Kaiser 102
 Polyphony 104
 Still Glows 104, *105*
 Three Houses and a Bridge 102, 104
Kusama, Yayoi 106–8
Dots Obsession 108
 'Infinity Net' paintings 106
 Kusama's Self-Obliteration 108
 Pumpkin 108
Lanyon, Peter 144
Larionov, Mikhail 182
Lapper, Alison 164, *164*
Leach, Bernard 144
Léger, Fernand 42, 110–13
 The City 113
 Contrast of Forms 110, *112*
 Leisure (Homage to Jacques-Louis David) 113
 The Smokers 110
 Three Women (Le Grand Déjeuner) 113, *113*
Leonardo da Vinci 52, 92, 200
Letterist movement 56
Lichtenstein, Roy 114–16
 Barcelona Head 116
 Brushstroke with Splatter 116
 Cubist Still Life 116
 Look Mickey 116
 Perfect/Imperfect series 116
 Salute to Painting 116
 Three Landscapes 116
 Whaam! 114, 116
Lucas, Sarah 162
Magritte, René 118–21

Empire of Light 120, *121*
 The Human Condition 120
 The Road to Damascus 120
 Treachery of Images 118
Malevich, Kasimir 166
Marc, Franz 100
Masson, André 26
Matisse, Henri 30, 122–5, 182
 Blue Nude Memory of Biskra 124
 Chapelle du rosaire 125
 Dance 124, 125
 Jazz 125
 The Joy of Life 122
 Luxe, calme et volupté 122
 Memory of Oceania 122
 Music 124
 Odalisque with Red Culottes 124
 Portrait of Mme Matisse/The Green Line 124
 Reclining Nude I 124
 The Red Room (Harmony in Red) 124, *124*
 The Snail 125
Mayakovsky, Vladimir 168
Millet, Jean François 46, 49
Minimalism 188
Minton, John 62
Miró, Joan 26, 126–9
 The Birth of the World 128
 Blue II 129
 Constellations 129
 The Farm 126
 The Hunter (Catalan Landscape) 126, *128–9*
 The Reaper 129
Modernism 142, 146, 148
Modigliani, Amedeo 130–3
 Head 130
 Head of a Woman 132
 Jeanne Hébuterne in Yellow Sweater 133
Mondrian, Piet 116, 134–7, 142
 Broadway Boogie Woogie 137, *137*
 Composition with Red, Blue and Yellow 136
 Flowering Appletree 134
 Grey Tree 134
Moore, Henry 70, 138–40
 Madonna and Child 140
 Reclining Figure 140
 Reclining Mother and Child 140
 Two Forms 140
Morita, Shiryu 212
Münter, Gabriele 98
Muybridge, Eadweard 14, 50

Neo-Dadaism 90
Neo-Impressionism 110, 122, 134
Neo-Plasticism 134, 136
Nicholson, Ben 70, 137, 142–5
 August 1956 (Val d'Orcia)
 144–5, 145
 1932 (Au Chat Botté) 142
 1935 (white relief) 144
 1943-45 (St Ives, Cornwall) 144–5
Nolan, Sidney 146–8
 Burke 148
 Inland Australia 148
 Ned Kelly 146, 148, *148*
 Pretty Polly Mine 148
O'Keeffe, Georgia 150–2
 Blue and Green Music 150
 Red with Yellow 152, *152*
 Sky above Clouds IV 152
 Two Calla Lilies on Pink 150
Ozenfant, Amédée 113
papier collé 32, 156
Perov, Kira 194
Picasso, Pablo 49, 82, 130, 146, 154–7
 Guernica 128–9, 154, *156–7*, 157
 influence on other artists 14, 102, 114,
 116, 138, 142, 182
 Las Meninas series 157
 Les Demoiselles d'Avignon 30, 154
 'Rose Period' 154
 Studio with Plaster Head 157
 'Synthetic Cubism' 30, 32, 76, 110, 124
 Three Women at the Spring 156
 Vollard Suite 157
Pollock, Jackson 60, 158–60
 Bird 158
 Male and Female 158
 Number 1, 1950 (Lavender Mist) 160, *160*
 Portrait and a Dream 160
Pop Art 20, 52, 86, 90, 106, 114, 116,
177, 198
Post-Impressionism 50, 122, 210
Quinn, Marc 162–4
 Alison Lapper Pregnant 164, *164*
 Garden 162
 Portrait of Sir John Edward Sulston 162,
 164
 Self 162
 Siren 164
Rauschenberg, Robert 10, 12, 90, 186
Ray, Man 52
Renoir, Pierre-Auguste 120, 190
Rivera, Diego 94, 96
Rodchenko, Aleksandr 166–9
 About This 168

Expressive Rhythm 168
'News of the Day' Advertising Poster 169
Non objective Painting Composition 66/86:
Density and Weight 166
 Steps 168
 Taxi Driver 168
Romanticism 58
Rothko, Mark 170–2
 Black on Maroon 172
 Horizontal Vision 170
 No. 3/No.13 172
St Ives School 144
Schwitters, Kurt 90, 174–7
 En Morn 177, 177
 Merz magazine 177
 Merzbild 1A: The Psychiatrist 176
 Mz 252. Coloured Squares 177
Section d'Or 50
Seven and Five Society 142
Sherman, Hoyt L 114
Spencer, Stanley 178–80
 Beatitudes of Love 180
 *Double Nude Portrait: Leg of Mutton
 Nude* 180
 The Resurrection, Cookham 178, *180*
 The Resurrection: Port Glasgow 180
 The Resurrection of the Soldiers 178, 180
 Swan Upping at Cookham 178
 *Travoys Arriving with Wounded at a
 Dressing-station at Smol, Macedonia,
 September 1916* 178
Stepanova, Varvara 166, 168
Stieglitz, Alfred 150
Suprematism 166
Surrealism 14, 26, 36, 38, 40, 46–9, 52,
58, 62, 66, 68, 104, 118, 120, 126, 140,
156, 158, 170, 210
Symbolism 38, 134
Tatlin, Vladimir 166, 182–5
 Corner Counter Relief 182
 Monument to the Third International 184,
 185
 Nude 184
 Rhythmic Nudes 182
 The Ten 170
Twombly, Cy 186–8
 Ferragosto II 186, 188
 The Four Seasons series 188
 Treatise on the Veil 188
 Untitled (A Painting in Nine Parts) 188
 Winter 188
Unit One 140, 142
Utrillo, Maurice 190–2
 Bayonne Cathedral 190

The Birthplace of Joan of Arc 192
Rue Saint-Rustique 190, *192*
Street Scene 192
Valadon, Suzanne 190
van Gogh, Vincent 14, 58, 202
Velázquez, Diego 14, 157
Viola, Bill 194–6
 The Greeting 194, 196, *196*
 He Weeps for You 194
 Heaven and Earth 194
 Nantes Triptych 196
 The Passions 196
Vlaminck, Maurice 122
Wallinger, Mark 162
Wallis, Alfred 142
Waqialla, Osman 56
Warhol, Andy 52, 92, 106, 198–201
 Big Campbell's Soup Can (19¢) 198, *200*
 Disasters 200
 Double Mona Lisa 200
 Empire 200
 Four Marilyns 198, *200*
 and Jean-Michel Basquiat 18, 20, 21
Whiteley, Brett 202–4
 Alchemy 204
 Big Orange (Sunset) 204, *204*
 (Free standing ultramarine) Palm Trees 204
 Listening to Nature 204
 Terrace Houses 202
 Untitled Red Painting 202
 Working Group of Constructivists 168
Xiaogang, Zhang 206–8
 Bloodline: Big Family, No.2 206, 208, 208
 My Dream: Little General 208
 Three Comrades 208
Yoshihara, Jir 210–12
 Please Draw Freely 212
 White Circle 212
 White Painting 210
 Work 212
Young British Artists 162, 164
Zox, Larry 214–16
 Gemini Series 1 *216*
 Orange Time 214
 Rotation B 216

222

PICTURE CREDITS

akg-images © DACS, 2015 177.
Archives H Matisse © Succession H Matisse/DACS 2015 124, 125.
Art Gallery of New South Wales Gift of Patrick White 1975 © Wendy Whiteley 204.
Courtesy **Bill Viola Studio** 196 above & below. Photos Kira Perov. Additional credits: performers in The Greeting are Angela Black, Suzanne Peters, Donnie Snyder.
Bridgeman Images De Agostini Picture Library 137; Empire State Plaza Art Collection, Albany, New York/Photo Boltin Picture Library © Artists Rights Society (ARS), New York (NY) and DACS, London 2015 216 below; National Gallery of Art, Washington DC © The Pollock Krasner Foundation/ARS, NY and DACS, London 2015 160; National Gallery of Australia, Canberra/Gift of Sunday Reed 1977 148; Private Collection/Christie's Images © the artist 208; Private Collection © The Lucian Freud Archive/Bridgeman Images 64.
Corbis Burstein Collection © Morgan Art Foundation/ARS, NY and DACS, London 88; Christie's Images 136; Christie's Images © The Andy Warhol Foundation for the Visual Arts, Inc/ARS, NY and DACS, London 2015 201; Daniel Gonzalez Acuna/Demotix © The Henry Moore Foundation. All Rights Reserved, DACS 2015/www.henry-moore.org 140; Derek Bayes/Lebrecht Music & Arts © ADAGP, Paris and DACS, London 2015 60; Francis G Mayer 80; Georgios Kefalas/epa © The Estate of Alberto Giacometti (Fondation Giacometti, Paris and ADAGP, Paris), licensed in the UK by ACS and DACS, London 2015 68; Manfred Rehm/dpa © DACS 2015 24; The Gallery Collection/Chagall ®/© ADAGP, Paris and DACS, London 2015 37; Walter Bibikow/JAI © The Easton Foundation/DACS 2015 29.
Getty Images Dan Regan 164; Hulton Archive © Bowness, Hepworth Estate 72; Marco Secchi © David Hockney 76; Matt McClain for The Washington Post via Getty Images © National Gallery of Art, Washington

DC 116; Peter Macdiarmid/Getty Images for The Hepworth Wakefield © Bowness, Hepworth Estate 73; Tony Vaccaro © Georgia O'Keeffe Museum/DACS 2015 152; Walter Mori/Mondadori Portfolio via Getty Images 133.
Photo **Giulia Hetherington** 185.
Via **Hauser & Wirth** photo Hidoto Nagatsuka/courtesy of the Hachotksy Collection © Shinichio Yoshihara/212.
Via **Louise Bourgeois Studio** photo Christopher Burke © The Easton Foundation/DACS 2015 28.
National Gallery of Art, Washington DC Chester Dale Collection 132.
Photo Scala, Florence Albright Knox Art Gallery/Art Resource, NY © The Josef and Anni Albers Foundation/VG Bild-Kunst, Bonn and DACS, London 2015 12; Art Resource, NY © 2015 Banco de Mexico Diego Rivera Frida Kahlo Museums Trust, Mexico, DF/DACS 96; BI, ADAGP, Paris © ADAGP, Paris and DACS, London 2015 121; BI/ADAGP, Paris © The Estate of Jean Michel Basquiat/ADAGP, Paris and DACS, London 2015 21; Christie's Images © ADAGP, Paris and DACS, London 2014 192; Christie's Images © The Estate of Francis Bacon. All rights reserved. DACS 2015 17, Digital image, The Museum of Modern Art, New York © ADAGP, Paris and DACS, London 2015 112, 113; Digital image, The Museum of Modern Art, New York © Cy Twombly Foundation 188; Digital image, The Museum of Modern Art, New York © DACS 2015 25; Digital image, The Museum of Modern Art, New York © Succession Miro/ADAGP, Paris and DACS, London 2015 128; Philadelphia Museum of Art/Art Resource, NY © Succession Marcel Duchamp/ADAGP, Paris and DACS, London 2015 52.
Courtesy **Stephen Haller Gallery** © Esate of Larry Zox 216 above.
SuperStock 100; Bridgeman Art Library © 2015 The Andy Warhol Foundation for the Visual Arts, Inc/ARS, NY and DACS, London

200; Chagall ®/© ADAGP, Paris and DACS, London 2015 36; Christie's Images 104; Christie's Images © ADAGP, Paris and DACS, London 2015 120; Christie's Images © The Estate of Jean-Michel Basquiat/ADAGP, Paris and DACS, London 2015 20; © DACS 2015 41; Fine Art Images 184; Fine Art Images © 1998 Kate Rothko Prizel & Christopher Rothko, ARS, NY and DACS, London 172; Fine Art Images © 2015. Banco de Mexico Diego Rivera Frida Kahlo Museums Trust, Mexico, DF/DACS 97; Fine Art Images © DACS 2015 176; Fine Art Images © Rodchenko & Stepanova Archive. DACS, RAO, 2015 169; Iberfoto © Salvador Dali, Fundacio Gaia-Salvador Dali, DACS, 2015 48; © Jasper Johns/VAGA, NY/DACS, London 2015 92; ImageBroker 108; Joseph Martin/Album © Succession Picasso/DACS, London 2015 156; Museum of Modern Art, New York © The Estate of Francis Bacon. All rights reserved. DACS 2015 16, Peter Willi © ADAGP, Paris and DACS, London 2014 32; Stefano Baldini/age fotostock 105; Tomas Abad © DACS 2015 40.
Tate, London © Angela Verren Taunt 2015. All rights reserved, DACS 144; © Ibrahim El-Salahi. All rights reserved, DACS 2015 57; presented by Lord Duveen 1927 © Tate, London 2015 180; © Saloua Raouda Choucair Foundation 44.
Courtesy **Vadehra Art Gallery**, New Delhi, India © Estate of M F Husain 84

ACKNOWLEDGEMENTS

No book would be complete without acknowledging those standing in the background with big, pointy sticks aimed at the small of my back when I falter. To quote the great advertising guru George Lois, 'having a mate who understands and contributes mightily to your ethos of life and work is a blessing beyond measure' and I'd like to count my blessings for having Libby as that mate. She has helped my work become what it is now, so she only has herself to blame when I produce another set of images on a whim. And by extension I couldn't possibly leave out Janet Wilkes, Libby's mother, who as an artist herself gave invaluable advice and support when things weren't going right with the work. I would also like to thank Hannah Knowles at Octopus for having the vision to imagine what this body of work could become and Chris Masters for his insights that breathe life into each artist's portrait.

Commissioning editor Hannah Knowles
Editor Pauline Bache
Designer Andy Tuohy
Picture researcher Giulia Hetherington
Assistant production manager Lucy Carter